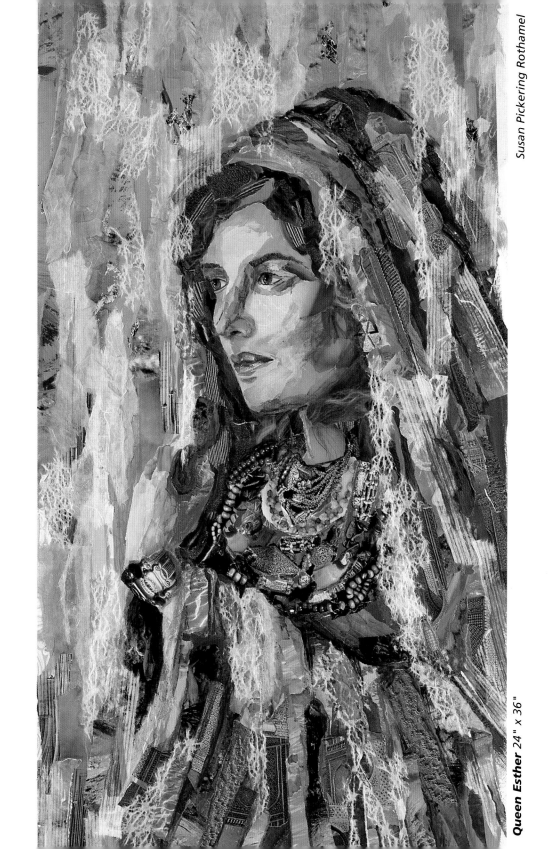

The Art of
Paper Collage

Susan Pickering Rothamel

Sterling Publishing Co., Inc. New York

A Sterling / Chapelle Book

Many thanks to:
Lori Mason—for her professional assistance, and without whom this project would have been impossible. Julie Davenport and Karen Strunk—for their help throughout the writing of this book. Barbara, Joanne, Lisa, Lorie, Patti, and Gidon—for "holding down the fort."

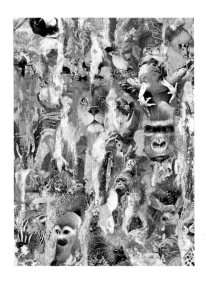

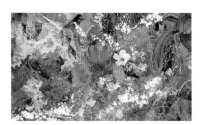

Chapelle, Ltd.:

 Owner: Jo Packham

 Editor: Laura Best

 Staff: Marie Barber, Ann Bear, Areta Bingham, Kass Burchett, Rebecca Christensen, Brenda Doncouse, Dana Durney, Marilyn Goff, Holly Hollingsworth, Susan Jorgensen, Barbara Milburn, Linda Orton, Karmen Quinney, Leslie Ridenour, Cindy Stoeckl, Gina Swapp

Library of Congress Cataloging-in-Publication Data Available

10 9 8 7 6 5 4 3 2 1

Published by Sterling Publishing Company, Inc.
387 Park Avenue South, New York, NY 10016
©2000 by Chapelle Ltd.
Distributed in Canada by Sterling Publishing
c/o Canadian Manda Group, One Atlantic Avenue, Suite 105
Toronto, Ontario, Canada M6K 3E7
Distributed in Great Britain and Europe by Cassell PLC
Wellington House, 125 Strand, London WCR2 0BB, England
Distributed in Australia by Capricorn Link (Australia) Pty Ltd.
P.O. Box 6651, Baulkham Hills, Business Centre, NSW 2153, Australia
Printed in China
All Rights Reserved

Sterling ISBN 0-8069-3942-7

This book is dedicated to:
David — who gently holds my kite strings, and Anne P. Turner, my aunt, my friend, and the one for whom the definition of unconditional love was written.

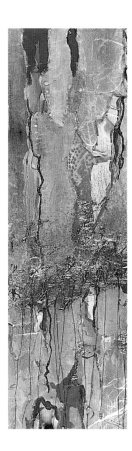

FOREWORD

All I can say is, "It's about time." If you've taken one of Susan Pickering Rothamel's classes or workshops; if you've seen her videos on collage and mixed-media techniques; if you know of her outstanding artwork, you'll agree with me—it's about time she wrote a book on the subject!

I've had the pleasure of working with Sue for a couple of years now. She writes a column for *Somerset Studio* on the business of marketing crafts and artwork, and her tips and techniques on using mixed media have often found their way into the pages of this magazine. Our readers are richer for her presence, for she dispenses her knowledge like candy at the Mardi Gras—freely, passionately, and with a generosity of spirit rarely found elsewhere.

In her videos, through her workshops, and now in this book, Sue bares all, keeping no secrets from her adoring fans (and you may count me in this group.) She carries on a tradition of educating young artists with this publication, which will surely find its way into many eager hands. I hope so, anyway.

If you know Sue, you can expect this to be an indispensable textbook, packed with information you'll use throughout your artistic career. If you don't know her, here's your opportunity to acquaint yourself with a generous, talented individual who will seem like a close friend before you've turned the last page.

Sharilyn Miller
Author, Stamp Art
Editor, *Somerset Studio*

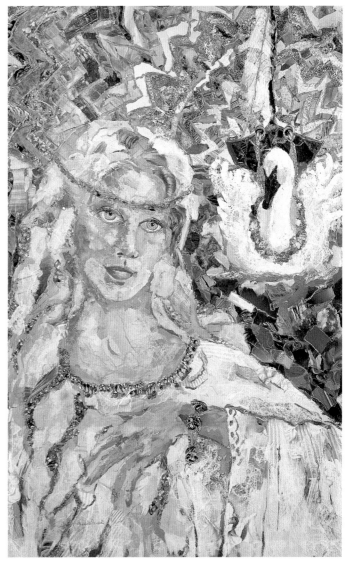

Elsa *28" x 40"* Susan Pickering Rothamel

Table of Contents

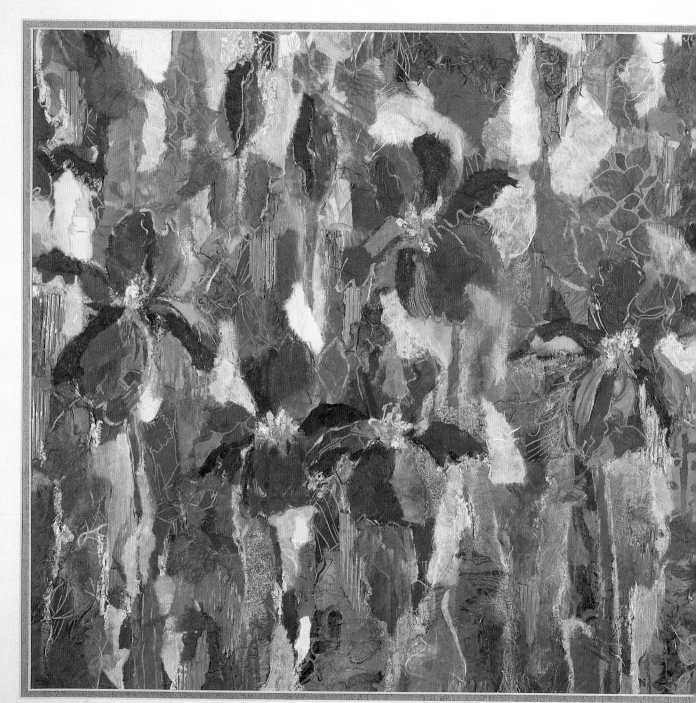

"*Flourishs*"
Hosea 14: 4-9

Introduction

Despite being nearly a century old and synonymous with innovative subject matter and revolutionary art materials, paper collage painting still has a way to go before it will be considered mainstream art. Fortunately, there is forward-thinking activity in the art community. Even hardened purists are beginning to see the light. Greater recognition of this art form seems to come from a growing interest of the public, demanding handmade and original art as well as the need for artists to create something good from the growing pile of refuse the world produces. Not just the art form of elementary children, it is not unusual to see several collage artists in a juried art show or museum.

As a medium, collage painting can be just as formidable as a watercolor, oil painting, or sculpture. The same compositional puzzles challenge the collage artist.

Color theory can be just as mysterious or elusive. In fact, when attempting collage, it can be downright difficult to achieve a sense of balance and harmony in form and content, much less have a working knowledge of the wide assortment of materials now accessible to create sound art.

The essential ingredient of collage is paper, and collage artists seem to be "paper packrats." Stuffed into drawers, stacked in piles, hoarded in envelopes, boxes, and bags are even the smallest bits of interesting paper. From shiny candy wrappers and old maps to fabulous handmade French marbles, from movie ticket stubs to elegant Oriental lace papers, the remnants are carefully selected by the artist and used to translate personal commentary into paper art.

Not for the faint of heart, it takes a true collagist to decorate

plain papers in a hundred different ways, and then have the fortitude to tear them into thousands of tiny pieces and turn them into art.

To begin that collage process, at least a rudimentary understanding is needed of the dozens of both traditional and contemporary art materials available to the collagist. I am proud to be among those who have become amateur inventors, technique aficionados, and art material junkies. No longer are we satisfied with oil, turpentine, and canvas; or a jar of water, a piece of 300 lb. paper, and a few tubes of pigment. There are those of us who have gone beyond adhering paper to paper, and have made it our life's work to experiment with paper making, marbling, paste-paper making, stamping, stenciling, thermal embossing, dry embossing; using scanners, computers, color-copiers, and more; thus expanding the title of collagist to mixed-media artisan.

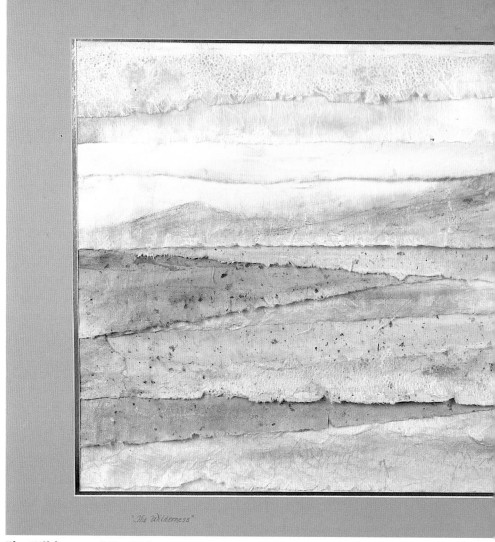

The Wilderness *24" x 32"*

Listen to collage artists to hear an interestingly varied conversation. Topics of discussion are curiously wide in nature. With an emphasis on the experimental, archival integrity becomes a subject of significant importance. Sounding futuristic, words such as reclaimed material venues, frakturs, and mail art punctuate the conversation of the mixed-media artists.

It seems, too, that collagists are inquisitive by nature. That curiosity translates into art that is exceptionally diverse in subject and materials. No more the simple landscape or portrait artist, collagists seem to be more diverse in subject matter. Using the same newspaper that brings us a daily bombardment of technological information, mind-boggling events, and light-speed overload, mixed-media artists incorporate it into the very art that appears to cross all creative boundaries and break every artistic rule.

Susan Pickering Rothamel

In the Beginning...

Most elementary children can recite the four items necessary to make a collage. A few scraps of paper, some adhesive, a surface for everything to be adhered to, and an idea. However, to produce a collage that is creatively inspired and enduring of color and construction—that is another thing.

There are those who will argue that product knowledge is nearly wasted on the beginning artist. They believe that anyone can play with materials in a totally carefree manner, and that one learns through the exploration process. While this may be true to a point, it can also be argued that art materials have their limitations and liabilities. Learning about art materials early on will enhance creativity.

Understand the process of correctly using materials, papers, and tools, then break the rules deliberately. Product knowledge assures an artist, either amateur or professional, of making creative and sound art. On occasion, learning things the hard way is often the only way. Early on, a palette-full of embarrassment could have been avoided had I just known a bit more about adhesives. This piece entitled "The Wilderness" is made of handmade paper—watercolored, then adhered to the surface board. It was exhibited in my first one woman show and among the first pieces sold.

This book is but a small attempt to show the several various processes of paper collage. By no means should anyone think it to be comprehensive. However, exceptional artists from around the country have added to the value of this book by imparting personal technical notes. To them, I would like to say thank-you. I deeply appreciate their courtesy and the inspirational work they have graciously shared.

I knew about paper and the value of using acid-free papers and paint. But, having come from a printing background, I was weaned on rubber cement. It was a natural glue for me to select. Easy. Neat. Fast. Much to my chagrin and just one year later, the owners of the painting called to tell me that, not only was it falling apart, but that the papers were discoloring right before their very eyes. From that awkward moment on, I began a quest for complete product knowledge. What a pity that I had to spend time to repair "The Wilderness" and spend several more months repairing an additional fourteen paintings. All would agree, that the time could have been much better spent creating new art.

Art, craft, rubber stamping, and fabric stores usually have someone who is knowledgeable of the products. Magazines, books, and videos all contain a nugget or two of information. These sources become invaluable to novices and experts. It is a life-long project to explore and experiment with new products.

The ultimate goal in experimenting with the new materials is not only to have fun, although that is an important aspect. Just as important, is learning strengths and weaknesses of materials, which then produces an understanding of creating art with archival integrity. Keep in mind, however, that integrity should never ultimately overshadow creative spirit.

GROUNDS & SUPPORTS FOR COLLAGE

For lightweight artwork that will be framed and under glass, use rag watercolor boards and papers, or mat board. For heavier work that will be framed, use hardboard, plywood, or stretched canvas.

It is important to avoid chipboard for any artwork. It contains acids which will discolor and deteriorate fine artwork.

Corrugated cardboard is a fabulous textural surface, and it may become essential for use. First flood cardboard with medium on all sides. Certain mediums will help to isolate acids from leaching into archival papers.

The working mat is the picture framing mat used to work out the composition of a collage—a much needed tool that tends to get overlooked. However, it is as important as any paintbrush, paint, or paper. Acquire these through a local frame shop no matter the size, even if they are damaged. Four strips of mat or foam-core board cut about three inches wide can be substituted for a working mat.

Mats are used to block confusing or extraneous edges and to help "find" the balance of shape, color, and form of a composition. Use them frequently while working a collage. Notice in examples throughout this book how mats are used to assist in determining composition.

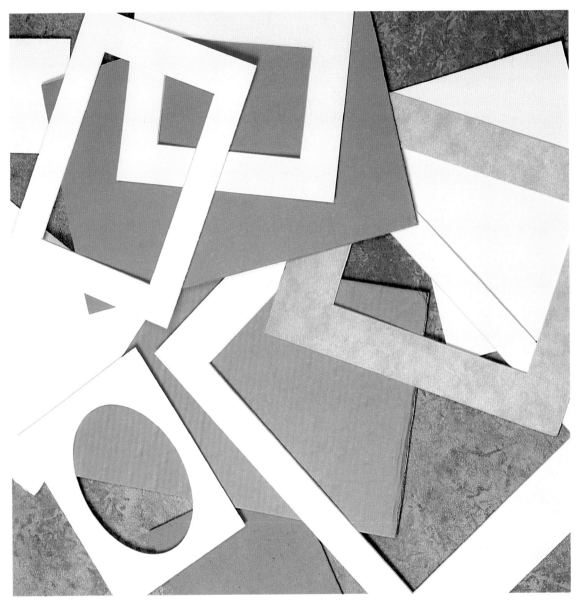

Tips: When applying papers and adhesive to only one side of a paper or board it may cause the sides to curl up. When using lighter-weight supports, such as watercolor paper or mat board, coat the back side of board with an acrylic medium to help prevent this warping. Once framed, the painting will lie flat.

Even when experimenting, use the best materials possible. One never knows when a study may evolve into a masterpiece.

Consider the weight of the materials to be applied to the surface and make the appropriate ground choice.

Suitable collage surfaces:

1. For lightweight collage, use mat board with acid-free rag surface.
2. For medium-weight collage, use 300 or 400 lb., 100% rag, acid-free, watercolor paper.
3. For heavy-weight collage, use hardboard with a thin layer of gesso.
4. For extra heavy-weight collage, use acid-free, 100% rag, watercolor board.

PAPERS FOR COLLAGE

When collaging, select papers that will give the greatest diversity, thus the greatest creative benefit. Whenever possible, choose acid-free or pH-neutral papers. Most magazine photographs and tissue papers are not suitable because they are not considered lightfast and will fade quickly.

Consider encasing all papers in an acrylic medium with UV protectants. This will help in keeping the colors truer longer, while isolating those less than perfect papers from those of archival quality.

Consider well each piece of paper for each piece of art. Every piece of paper is so different that it almost speaks to you on how it will be used in a particular collage. The voice may be a whisper or a shout. Therefore, it is not at all unusual to have a piece of paper for several years before it finds its way into the right piece of artwork.

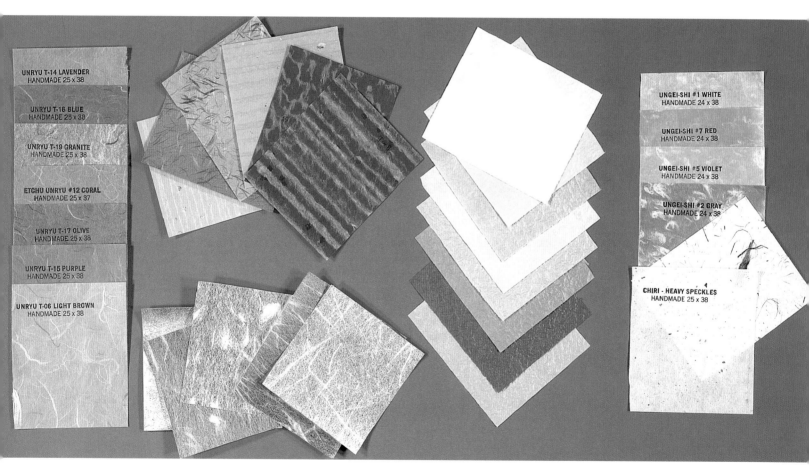

Japanese decorated papers—Mostly silk-screened, these are beautiful to look at, but can be limiting by their very nature and design.

Oriental papers—These luscious papers, as seen on page 14, come from a variety of Eastern countries, but are categorized as Oriental and are sometimes referred to as rice or mulberry paper. Rice or mulberries are seldom, if ever, the component of the papers available today. Oriental papers come in dozens of textures and colors. Some Oriental papers have no sizing, consequently they may absorb paint and adhesives quickly.

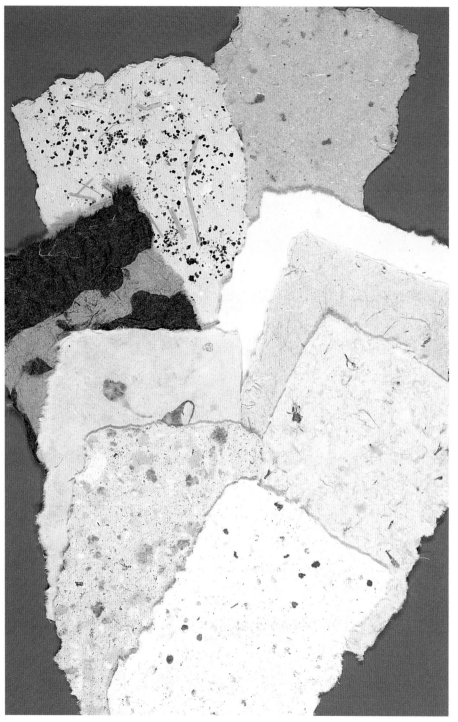

Hand-decorated papers—Any type of paper can be decorated, then used in collage. Many methods of decorating, such as paste-paper making, stamping, and more, will be covered in this book. Use acid-free plain papers for decorating.

Handmade papers—Gorgeous handmade papers can easily be made or purchased from other paper makers. Paper making is considered an art form, and its artists considered professionals in their own right. Handmade papers come in thousands of patterns, weights, and textures. Sizing may make a difference in adhesive and paint absorption.

Exotic paper-like surfaces—This huge category may include surfaces such as papyrus, bark, rayon, plastic-coated papers, and metal foils. These surfaces do not take adhesives as well as paper, but can be used successfully with a bit of perseverance. Generally, this means several coatings, or stronger bond adhesives applied to both surface and ground.

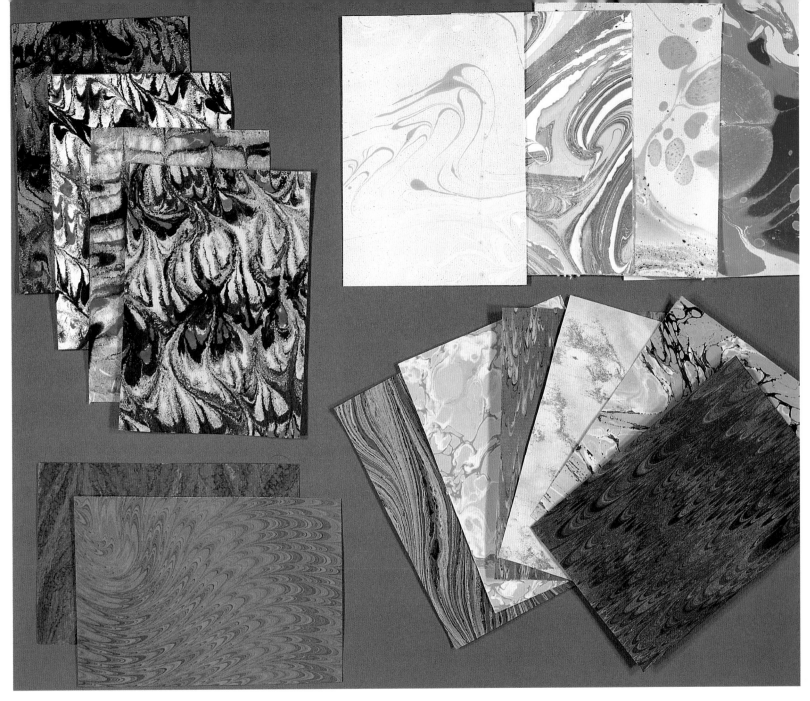

Marble papers—These resplendent papers add a unique and fresh look to a contemporary project. Whether handmade, machine-made, or printed, they add texture and colorful movement to any collage. The process of marbling paper is an art form unto itself and can be quite easily learned through books or classes. As a collagist, it is a technique worth trying at least once.

Lace papers—These delicate papers come in a variety of patterns and are useful in softening harsh colors and lines. They help to integrate an entire collage, and are beautiful accents. Since these papers are very thin and airy, they are likely to disappear if too much adhesive or medium is used.

Magazine photographs—Often seen as a specific object or subject, magazine photographs can also be viewed as colored paper or texture. Higher-end magazines buffer paper to achieve an acid-free condition. It is best to use them in isolation from other papers and apply a UV resistant/protectant to the surface to aid in achieving lightfastness.

Newspapers—These are wonderful to use as black and white texture, or for the words. Though newspapers are made of poor-quality paper, it may be just what you want. But remember to use plenty of medium.

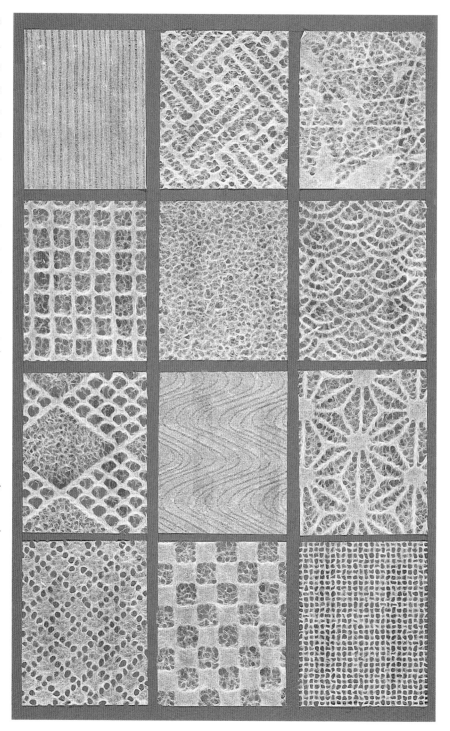

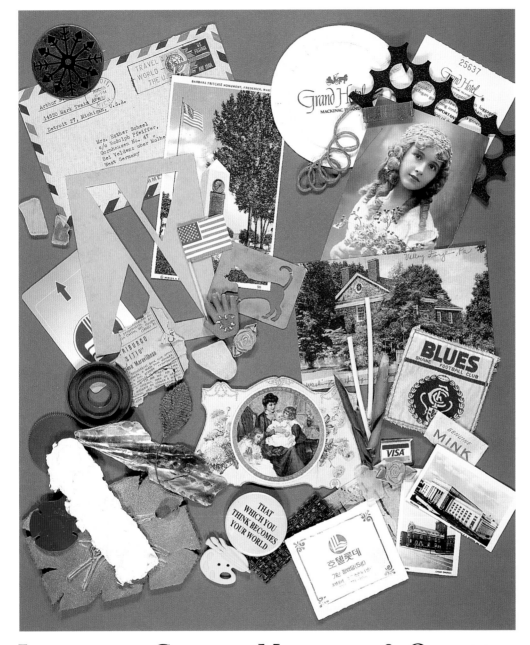

- wires
- sticks
- labels
- fabrics
- money
- stickers
- ribbons
- buttons
- postcards
- paper clay
- wallpapers
- beach glass
- plastic wrap
- photocopies
- polymer clay
- advertisements
- modeling paste
- postage stamps
- flattened metal
- strings & cords
- computer boards
- pages from old books
- records & compact discs
- pressed leaves & flowers

LOW-RELIEF COLLAGE MATERIALS & OBJECTS

Although these items may not be considered acid-free or archival, many offer diversity of texture, color, or relief that paper cannot match. Do not let that stop the creative flow. As with paper, isolate these items with plenty of medium.

ADHESIVES

Besides the paper itself, adhesives are the single most important aspect of paper collaging, yet seem to cause the most confusion. There is little difference between brand names and a large difference between types of adhesives due to distinctly different chemical compositions. Many adhesives require mixing, special tools for application, or exceptionally long drying times. Use a high-quality adhesive which is user-friendly and obtainable. Use the proper adhesive for each project—adding excess moisture to paper will make it wrinkle. Select an adhesive which needs little or no water, and dries fairly quickly. It is unnecessary to use a wet adhesive for simple paper layering—use a tape-like adhesive. Avoid using an applicator tip to apply adhesive to paper. Pour a small quantity into a container and use a good paintbrush for application of wet adhesives.

Acrylic—Acrylic mediums and adhesives come in both matte and glossy finishes. Acrylic gel mediums dry completely transparent, are sticky in application, and need water enhancing for smooth brushability on lightweight papers. Directly from the container, they are ideal for heavier-weight objects and thick boards. Perfect Paper Adhesive™ (PPA) is a unique UV resistant/protectant acrylic adhesive which needs no water for immediate application. It is smooth, not sticky and works well as a transparent sizing and adhesive for most papers. PPA must be applied in a thin film with a soft brush. It dries quickly, so minimal moisture absorbs into the paper. All acrylic-based adhesives are durable, flexible, and will not harden or crack. Use all acrylic products as mediums to be mixed with acrylic paint, dry pigment, and colorant.

Powdered—Methylcellulose, rice, and wheat come in powdered form and often require cooking. Prepared adhesives have a short shelf life, and in very humid climates, can develop mildew. However, these are considered archival and are reversible.

PVA (Polyvinyl Acetate)—These white glues are suitable for the most basic adhering applications but should not be considered acid-free or pH-neutral unless stated on the container. They come in a variety of thick, tacky, or thin weights, and are water soluble even after they are dry. This classifies PVA as archival because curators consider it reversible. These glues dry semigloss to glossy and are mostly transparent. It may be necessary to add water when working on more delicate papers. A glob dripped on the surface will leave a shiny spot.

Tapes—A variety of brands are available that are acid-free, pH-neutral, nonyellowing, and heat resistant. The difference is the ease of use and preference. Tapes are ideal for paper-layering and exotic art techniques.

Vegetable—This has a slightly higher pH than neutral, but has been used for years by collagists, and considered a necessary studio adhesive for those using heavier papers, boards, and objects. Apply with a spatula for heavy boards, and thinned with water for regular and lightweight papers. Care should be taken to reseal the jar after application to preserve the remainder.

Caution: Cellophane tape, masking tape, rubber cement, spray adhesives, and mucilage will all yellow, become brittle, and are not acceptable adhesives for fine art collage. Hot glue and two-part epoxy can be used under special conditions, but should not be considered archival. Hot glue will not maintain its integrity in heat or cold. Epoxy will turn amber-colored, so use it only where it will not be visible as with a pebble, metal pieces, or opaque glass.

SUPPORTING MATERIALS

The range of materials used in collage can span from a simple adhesive paintbrush and cup, to a virtual plethora of pencils, paints, pastels, and palettes.

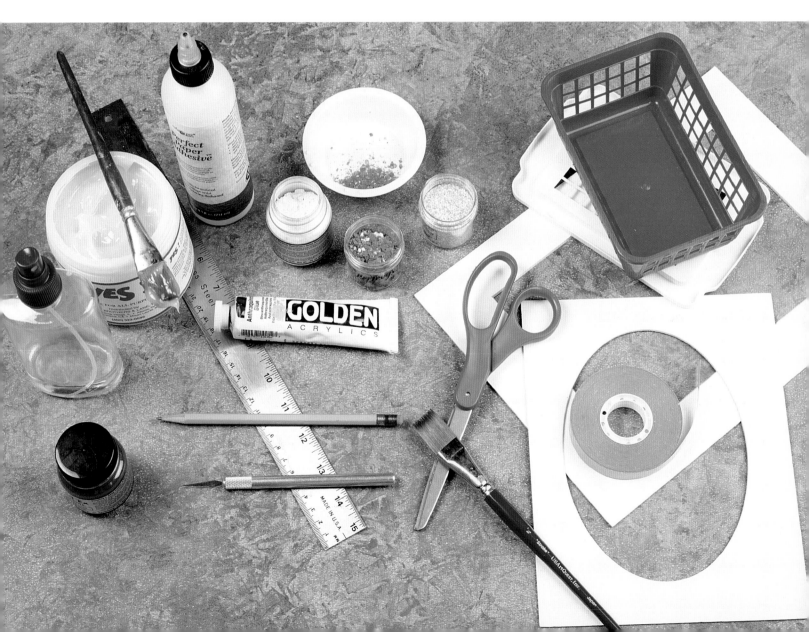

Collage Techniques

PAPER EDGES

Handmade papers tear differently from machine-made papers. To demonstrate, take any piece of white paper and tear it in one direction. Now tear it in the other. Notice that there is a definite grain in which the paper fibers tear. In one direction, they tear in a nearly straight strip. The other direction tears randomly. This is typical of any machine-made paper. Handmade papers tear randomly in both directions.

In handmade paper-making, fibers in the pulp stage float freely in the basin. When the mold and deckle are pulled through the pulp bath to form a sheet, the fibers are randomly scattered. Handmade paper sheets are stronger due to this random fiber patterning.

To obtain control when tearing handmade papers, draw a line across the paper, using a paintbrush and water. The paper will tear easily on the wet area. Even curves, arcs, and patterns tear from a sheet easily with this wet-edge technique. To obtain a straight edge, tear against a yardstick or ruler, leaving an edge similar to the natural deckle of handmade papers.

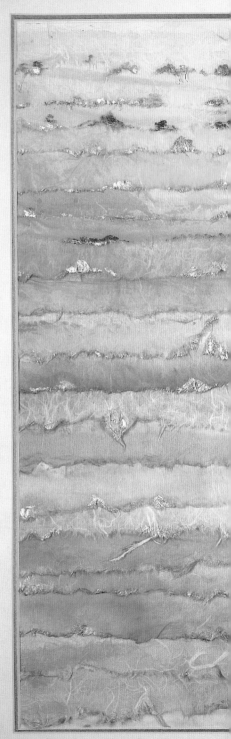

Handmade Oriental papers were torn, using the wet-edge method, for this project. Each piece was then water-colored, hung until dry, ironed, gold leaf tipped, and assembled.

"The Promises II"

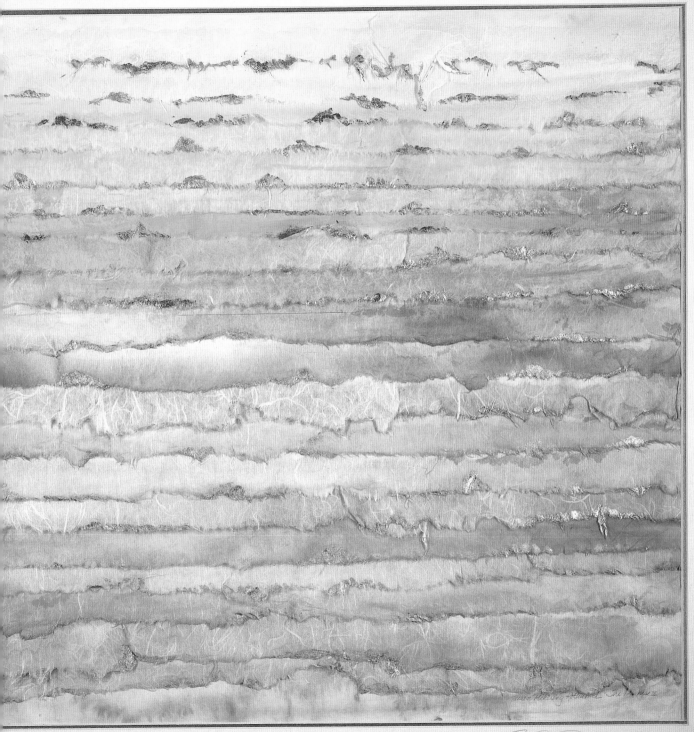

The Promise 32" x 40"

DECKLING TOOLS

A simulated deckled edge can be made by mechanical methods. Paper trimmers are particularly useful in cutting papers for paper layering. They produce a clean, decoratively cut paper edge. Special deckling rulers can be used for quick tears, and work especially well with soft papers.

Tearing magazines or photographs is an entirely different matter. Printed paper is white in the middle. The ink is only on the surfaces. Therefore, when it is torn, white edges will show. These white edges can be used to an advantage, much as a watercolorist uses the white of the paper to provide an illusion of light. If edges are distracting, the paper can be torn in such a way as to leave the white edge on the discarded piece. Practice with darkly printed magazine photographs to get used to tearing paper. Grasp paper and tear upward, and again downward.

PAPER LAYERING

Although a category of the paper arts, many people feel that paper layering is collage. However, paper layering is really only a "sort-of" collage. The stacking and layering of paper upon one another is most often used as an enhancement. Random layering is not considered formal collage art. Whereas the intermixing and weaving of papers to create a structured pattern or geometric design is formal collage art. Paper layering generally involves the incorporation of another art form or a background or framework for collage.

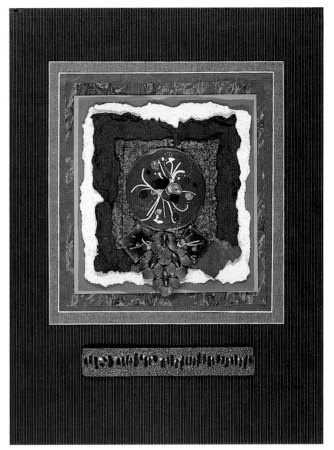

Feast of the Tabernacle Susan Pickering Rothamel
12" x 16"

These two pieces have made liberal use of paper, but they are stacked to create the framework for a main focal point. There is little or no integration or adhering of papers as in formal collage. This collage technique is called paper layering.

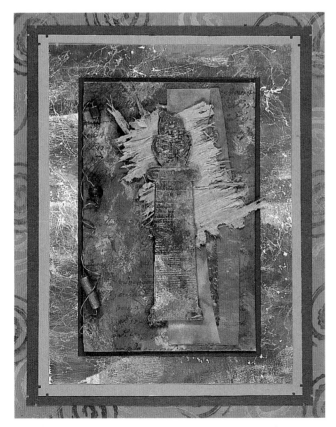

Untitled *8" x 10"* Lisa Renner

ASSEMBLAGE

Assorted objects, especially found objects, combined to form artwork with three-dimensional qualities are called assemblage. This type of artwork can be sculptural or framed art. Collage techniques are often used to achieve assemblage art and many times there is but a thin line between the two art forms. Sometimes, collage can be borderline assemblage. The differences lie in the integration of paper and just how much three-dimensional relief has been added. The following projects are examples that technically are assemblage art, but incorporate collage techniques.

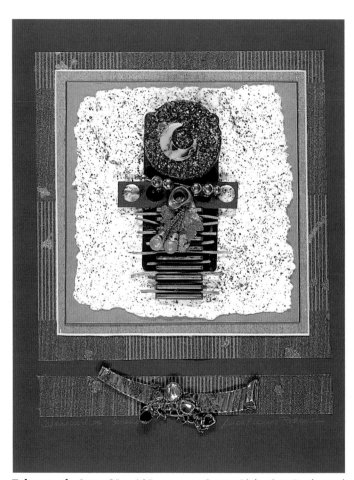

Tabernacle Icon *8" x 10"*　　　*Susan Pickering Rothamel*

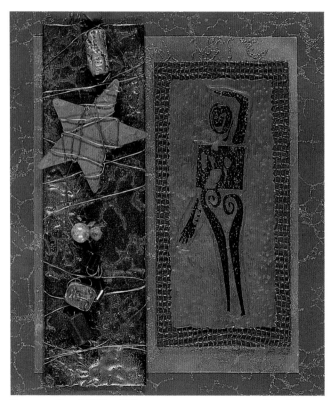

Copper Card *6½" x 7½"*　　　*Lisa Renner*

"Pearls of wisdom fell from the old bag's lips while in the background the crooner sang a tune she knew he had selected just for her."

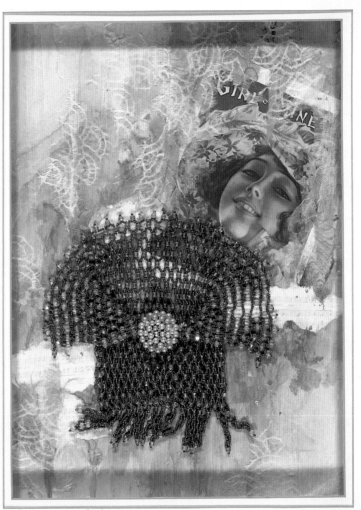

Many colors of watercolor were used as washes for the underpainting in this assemblage. A woman's image was taken from sheet music and collaged with lace and handmade papers. The very same sheet music was integrated into the collage and used as the backdrop for the Victorian beaded bag.

Pearls of Wisdom 16" x 20"

Susan Pickering Rothamel

27

DECORATIVE COLLAGE

Much like collage, découpage is the pasting of assorted materials, such as greeting cards, magazine pictures, newspapers, and other papers, onto a surface. However, the differences between collage and découpage usually lie in the imagery used and type of finish applied. Découpage requires sanding between coats of finish to achieve a completely smooth surface. Collage does not. Découpage usually incorporates figurative imagery. Collagists can use anything. Altering surfaces, such as tables, boxes, and lamps, adds a whole new perspective on collage.

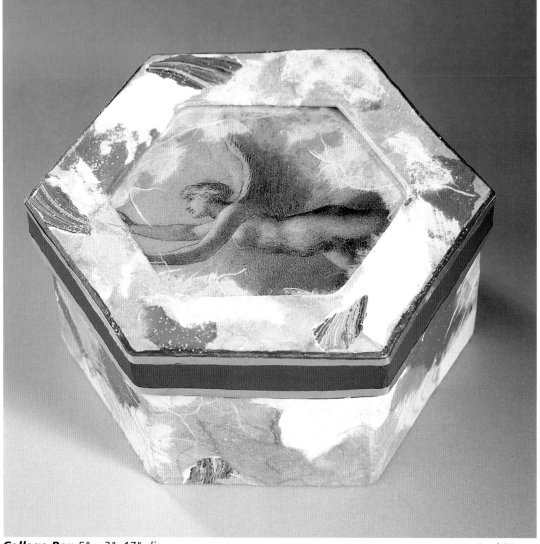

Dry pigment and acrylic adhesive were applied first to the box and allowed to dry. Magazine pictures and art papers created the theme while lace and marbled papers were used to integrate the images. Embellishments were added with paint, mica tiles, and mica flakes.

Collage Box *5" x 3"; 17" dia.*

Lori Mason

Violin Table
24" tall

*Susan Pickering
Rothamel*

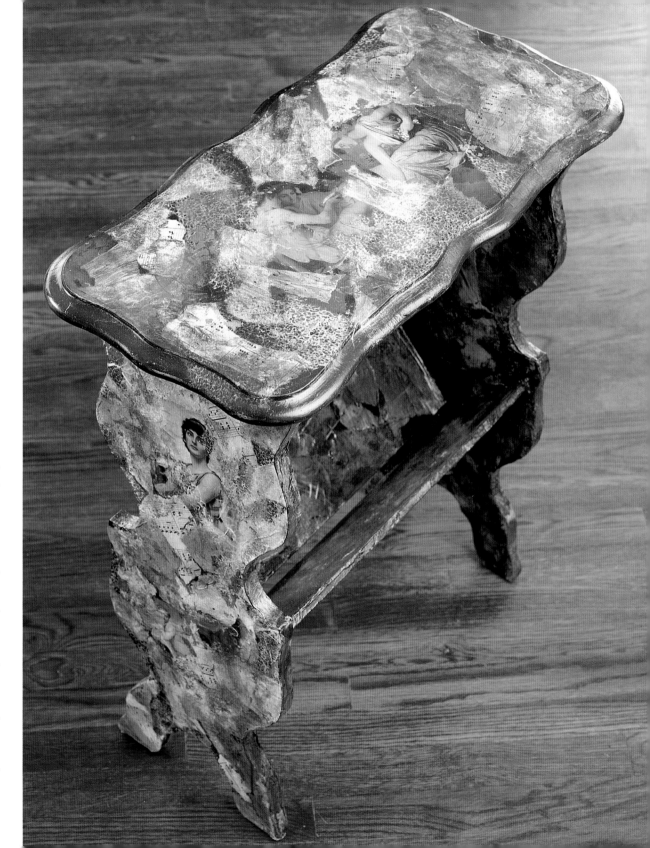

"This table hung around the house for years until just the right papers were found to enhance its unique violin-like shape. Antiquing the entire collaged and painted table helped a little. But although the papers still seem a trifle loud, I find that sometimes creating work that is offbeat and a bit outrageous is a lot of fun. This table is destined to become a conversation piece in any room."

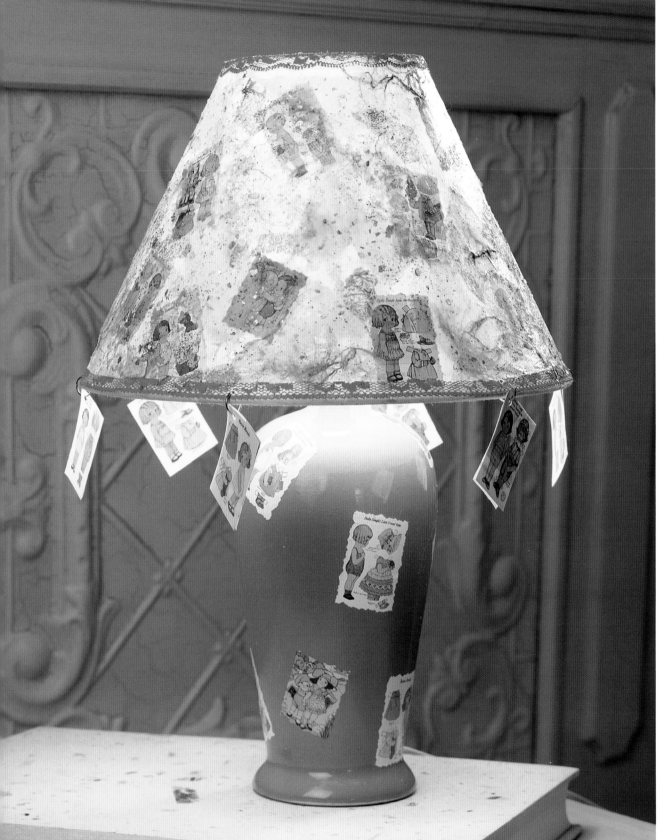

"Dolly Dingle" Child's Lamp
15" lamp

Susan Pickering Rothamel & Lori Mason

Small cutouts of the paper doll "Dolly Dingle" were découpaged to the base of the lamp. More Dolly images were collaged to the shade along with lace and art papers. Mica flakes added a touch of sparkle. Single Dolly images were laminated and attached to the shade with jump rings to add kinetic whimsy.

RUBBER STAMP MAKING

Rubber stamping and heat-embossing, although traditionally considered a craft or card-making art, have made inroads into the art industry. Introducing stamped images and stamped papers into paper collage painting can produce exciting, subtle patterning and striking representational imagery. If originality is of prime importance, and using one of the thousands of stamps available at a local store is not your style, carving an original rubber stamp is easy and fun.

Tip: For larger images, rubber cement several erasers together.

Materials needed:
- Craft knife
- Ink pad
- Linoleum carving tools
- White eraser (any will do, but white is the smoothest to cut)

1 Draw image onto eraser, using a pen or pencil.

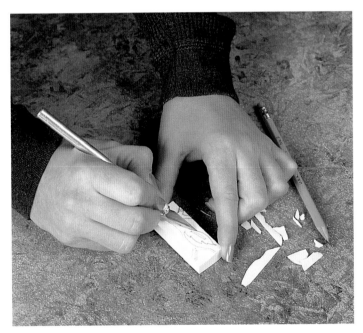

2 Carve away eraser that is not part of the design.

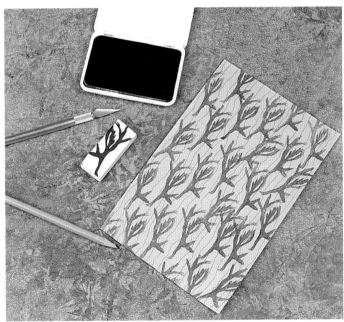

3 Stamp a single image or an overall pattern.

RUBBER STAMPING
USING DRY PIGMENT

Using manufactured stamps in collage can be helpful for those who want a representational image, but are unable to produce it themselves. With virtually thousands of images to select from, they can easily mix and match, even using several simultaneously. Using nontraditional paper can also transform an ordinary stamp into something quite remarkable, particularly when used in conjunction with a nontraditional art material, such as dry pigment.

Materials needed:
- Dry powdered pigments
- Pigment ink stamp pad
- Rubber stamps (hand-carved or manufactured)
- Small detail paintbrush
- Soft, wide paintbrush

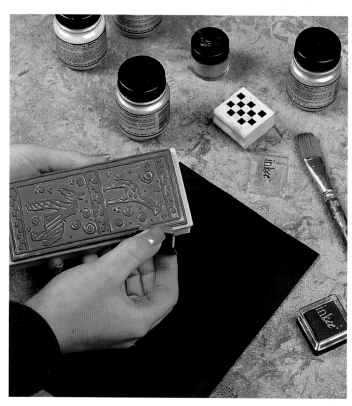

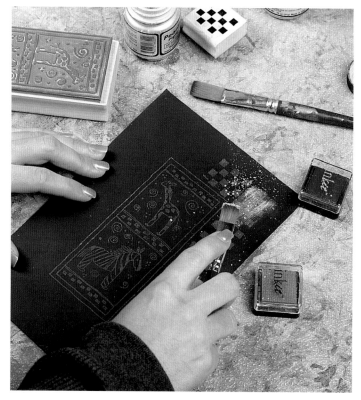

1 Stamp an image with pigment ink onto piece of plain or textured paper to create design.

2 Using border image, repeatedly stamp while rotating paper frequently to achieve overall patterning. Dip small paintbrush into dry pigment. Dust various colored pigments onto stamped image.

3 When entire stamped image is covered with pigment, use a clean, dry, soft, wide paintbrush to gently but vigorously sweep off excess pigment. Spray with a clear finish to prevent smearing.

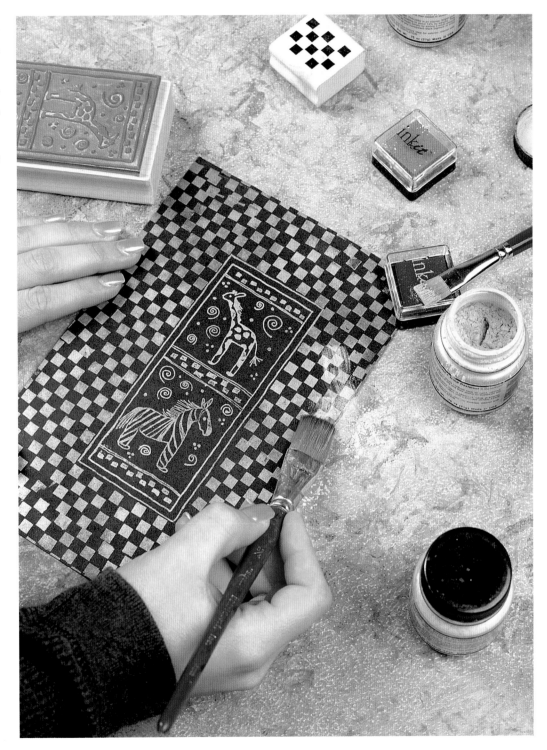

RUBBER STAMPING & HEAT EMBOSSING

Materials needed:
- Embossing powder
- Heat tool
- Pigment ink stamp pads
- Rubber stamps (hand-carved or manufactured)

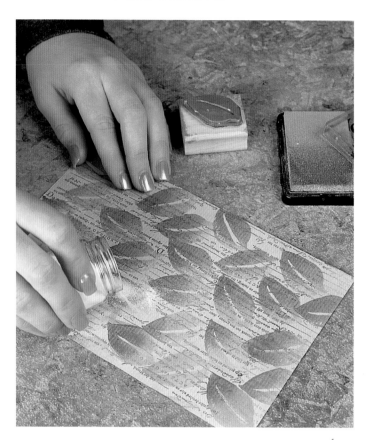

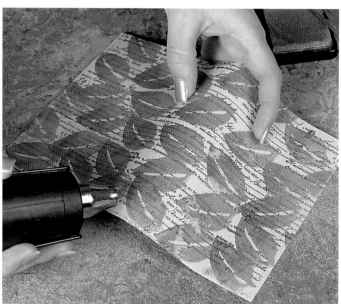

2 Tap off excess and heat-emboss.

1 Stamp with pigment ink onto paper, using a textural background stamp. Overstamp with any other stamp. Sprinkle embossing powder onto the image.

Tips: For abstract textures and patterning, consider using only parts of a representational imagery. It is considered good composition to partially stamp on the edges of paper for an all-over pattern.

To avoid blowing tiny particles into the air, try heat-embossing powders from underside of artwork.

Studio Safety: Wet wipe, wet mop, and then vacuum after every workday and between long working sessions. Using a dry cloth will only smear particles around. Embossing powders, glitter, dry pigments, and other loose materials easily blow about when using an embossing tool. Even after carefully tapping off excess powder into a lined waste receptacle, there are still microscopic "fines." These fines are blown into the air and can be inhaled. While most of these particulants are nontoxic, they are messy. Still, care should be taken to avoid inhalation.

Stamped papers were integrated into this piece. As the piece neared completion, over-stamping was added to strengthen the compositional patterning and theme.

"The Season of Singing"
Song of Solomon 2:10-12

Susan Pickering Rothamel

"My beloved spake, and said unto me, Rise up, my love, my fair one, and come away. For, lo, the winter is past, the rain is over and gone."
Solomon 2:10-12

Season of Singing 16" x 20"

Susan Pickering Rothamel

ACRYLIC PAINT COLLAGE

Although it is great fun to randomly place papers during the collage process, beginning a painting with a sketch and acrylic underpainting accomplishes two things: it allows for instant corrections in composition, and it creates a rich color-saturated layer that radiates through the paper layers placed on top. The use of acrylic paints also means paint will not bleed through papers as watercolor paint, pencil, or gouache will.

Materials needed:
- Acrylic paints
- Adhesive
- Assorted art papers
- Magazine pictures or photographs of flowers
- Paintbrushes
- Pressed or dried flowers (optional)
- Watercolor paper

There are scores of symmetrical and asymmetrical compositional schemes. Here are three that will assist in achieving a well-balanced picture.

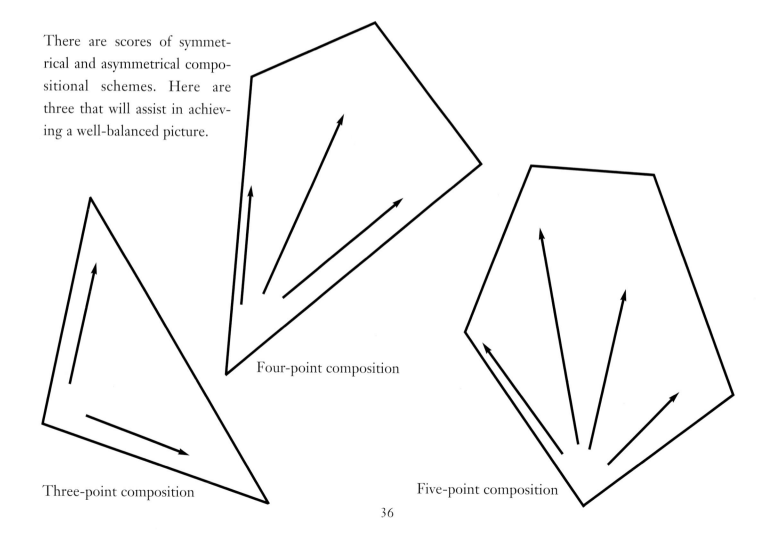

Four-point composition

Three-point composition

Five-point composition

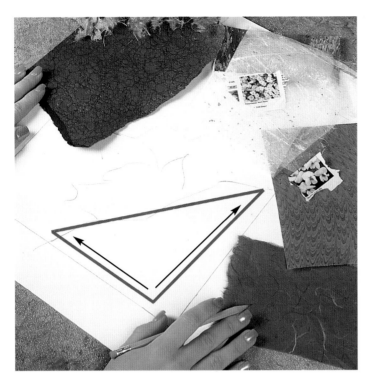

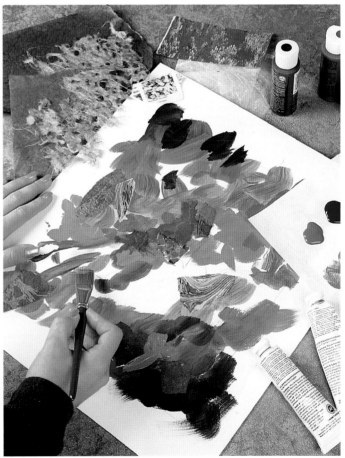

2 Liberally paint in the sketch with desired acrylic colors. Locate focal points with contrasting color patches. Use paint to roughly plan out color scheme. This is called an underpainting sketch.

1 Select a general group of papers for composition. It is not necessary to lock in on all of the exact papers that will be used. It is best to select a light, medium, or dark value grouping. For this example, dark values of green are the overall selection. However, note that off-white Oriental papers have also been selected. This is because the underpainting colors are dark. Oriental papers, when placed on top, will appear to be muted shades of the underpainting. Lightly sketch the basic idea on watercolor paper or mat board with pencil. This example will use the three-point composition drawing. Refer to page 36. Leave enough room around paper edge for a mat by measuring in at least 2" from edge.

3 Tear assorted papers into different sizes and shapes. Sort papers into similar color piles, so they are easily accessible. Arrange and layer torn pieces of paper on top of acrylic underpainting. Adhere papers when composition and color balance are satisfactory. Use a mat to check balance and color placement.

Note: It is acceptable to put a UV-resistant matte finish adhesive over the layers of paper. This will particularly protect less than lightfast magazine photographs. Lace papers make lovely highlights. However, be gentle with this type of paper so that the ethereal lace-like quality remains. Too much adhesive will make it disappear. Other additions, such as the use of watercolor, acrylic, or metallic leafing pens can be used to enhance and highlight the focal point. These additions will also strengthen line and composition.

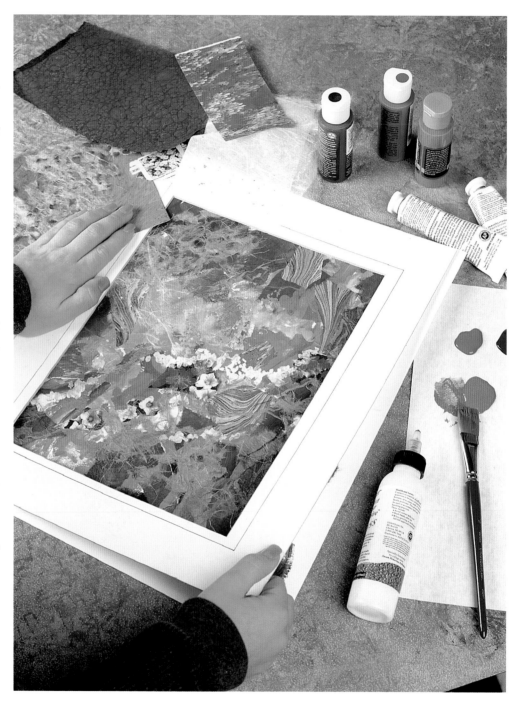

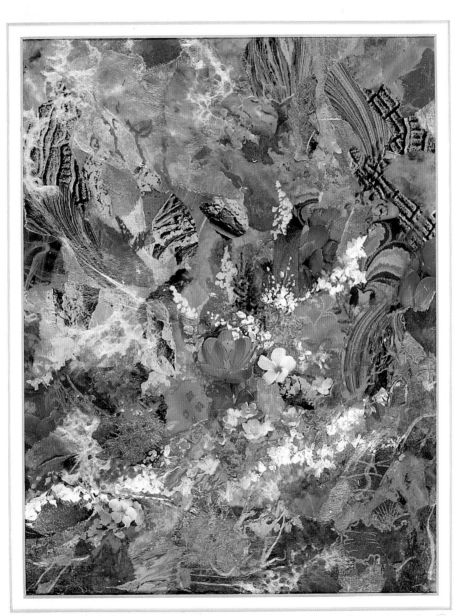

"Within the Garden"
Genesis I

Susan Pickering Rothamel

Within the Garden 14" x 16" Susan Pickering Rothamel

MAGAZINE PAPER COLLAGE

Using magazines as resources for artwork can produce many positive results. They are inexpensive, easily available, and have thousands of subjects, patterns, and textures. Select material from magazines that have quality paper or copy favorite images onto high-quality paper at a copy center.

Note: Some copy shops do not allow copies from books or magazines to be made, due to copyright laws. A way around this problem is to cut and paste the type or pictures, onto another piece of paper first. Be certain to understand and follow basic copyright laws when creating artwork to sell.

Materials needed:
- Acrylic paints
- Adhesive
- Assorted art papers
- Magazine photographs
- Paintbrushes
- Scissors
- Watercolor paper

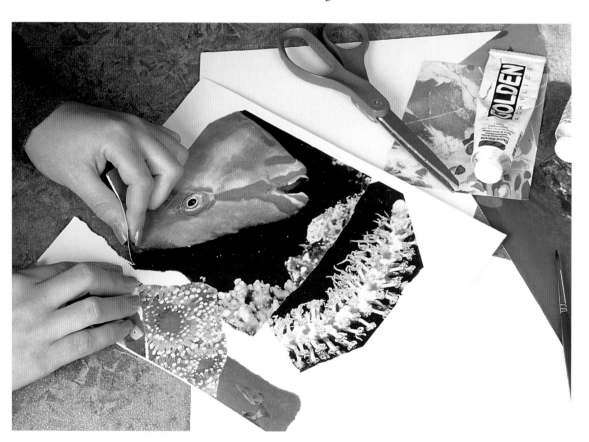

1 After selections have been made, begin by tearing away excess paper, leaving only the imagery. As with any painting, when working a collage, do not concentrate on one area. Work the whole piece.

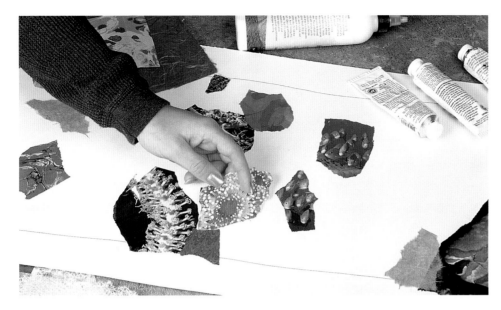

Tip: Before positioning the mat, paint a neutral-colored border around the finished artwork. This will cover any white edges that might have been missed with the paper.

2 Continue to work the entire painting. Locate negative spaces while defining positive imagery with paper or paint, or a combination of both.

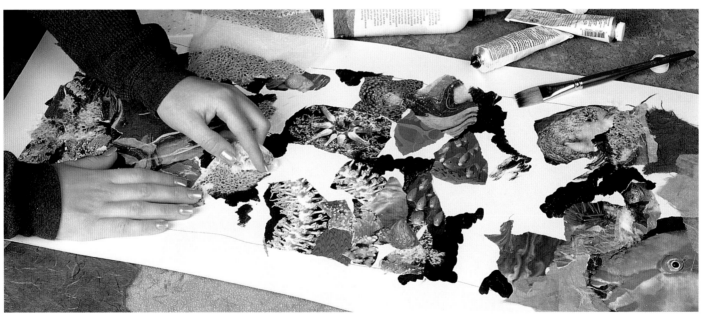

3 Mix a delicate glaze of gloss adhesive and a drop each of blue and umber paint. The glaze will soften the more garish colors of the magazine photographs and color copies, giving the impression of looking through water. Lace papers can be added both to decorate and to soften bold edges and colors. Lace papers come in so many textures that it is possible to have some that replicate textures in the photographs.

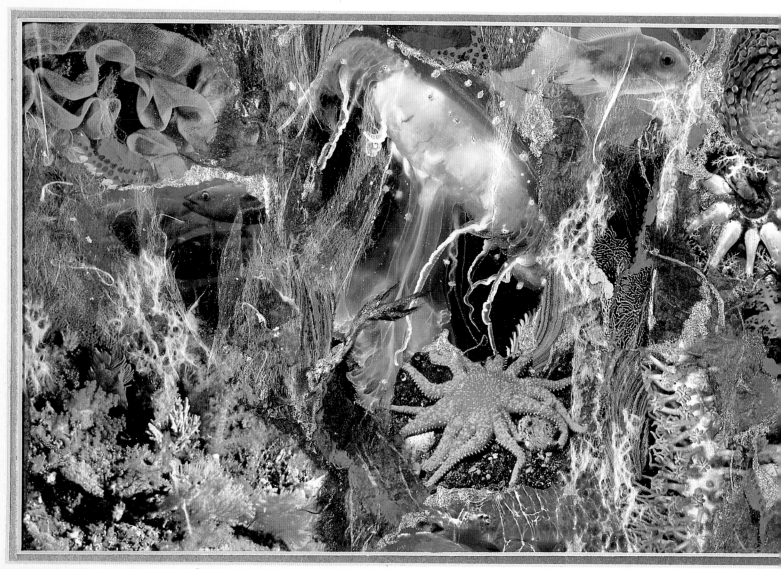

"All the Creatures of the Deep"
Genesis I: 20-23

All the Creatures of the Deep
14" x 32"

"And God said, Let the waters bring forth abundantly the moving creature that hath life, and fowl that may fly above the earth in the open firmament of heaven. And God created great whales, and every living creature that moveth, which the waters brought forth abundantly, after their kind, and every winged

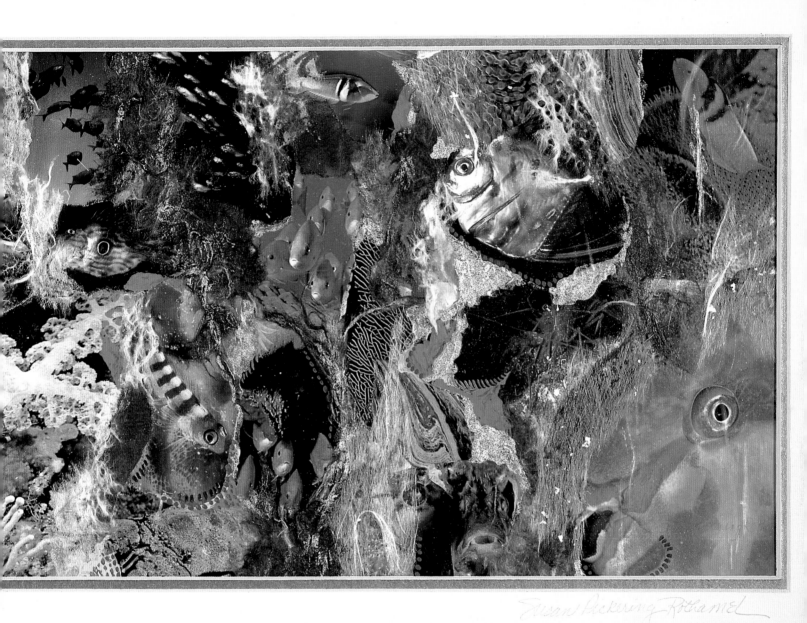

Susan Pickering Rothamel

fowl after his kind: and God saw that it was good. And God blessed them, saying, Be fruitful, and multiply, and fill the waters in the seas, and let fowl multiply in the earth. And the evening and the morning were the fifth day." Genesis 1:20–23

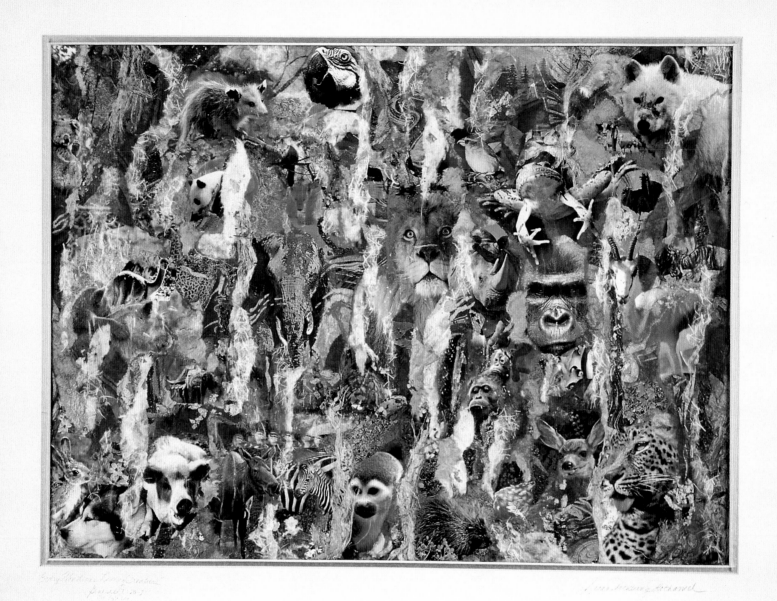

Every Wondrous Creature 28" x 32"

Susan Pickering Rothame

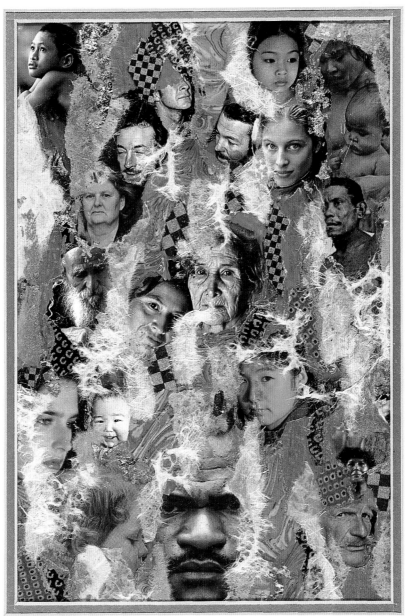

"The Sixth Day"
Genesis I

Susan Pickering Rothamel

The Sixth Day *8" x 12"*

Susan Pickering Rothamel

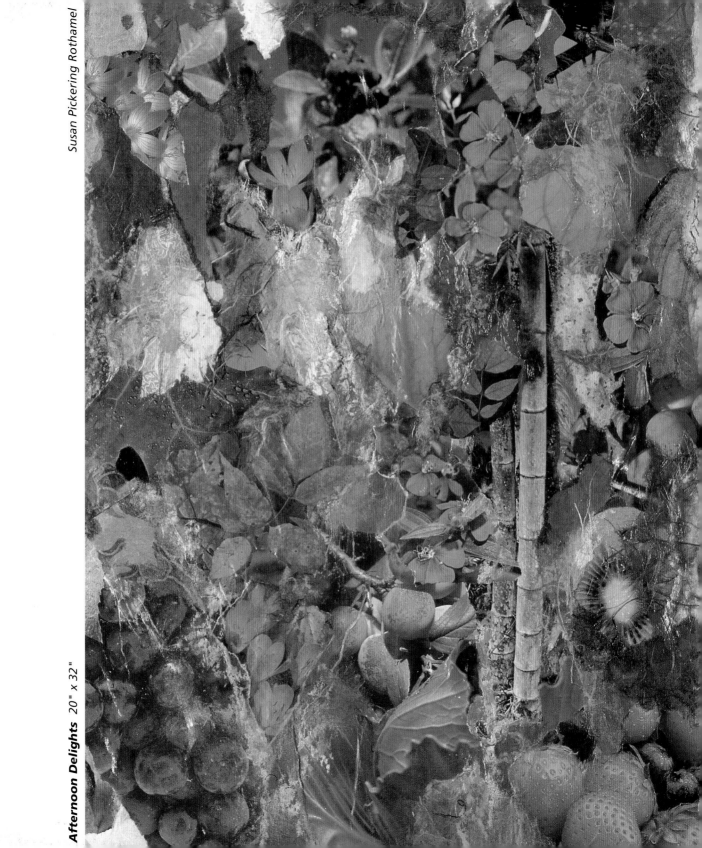

Afternoon Delights *20" x 32"*

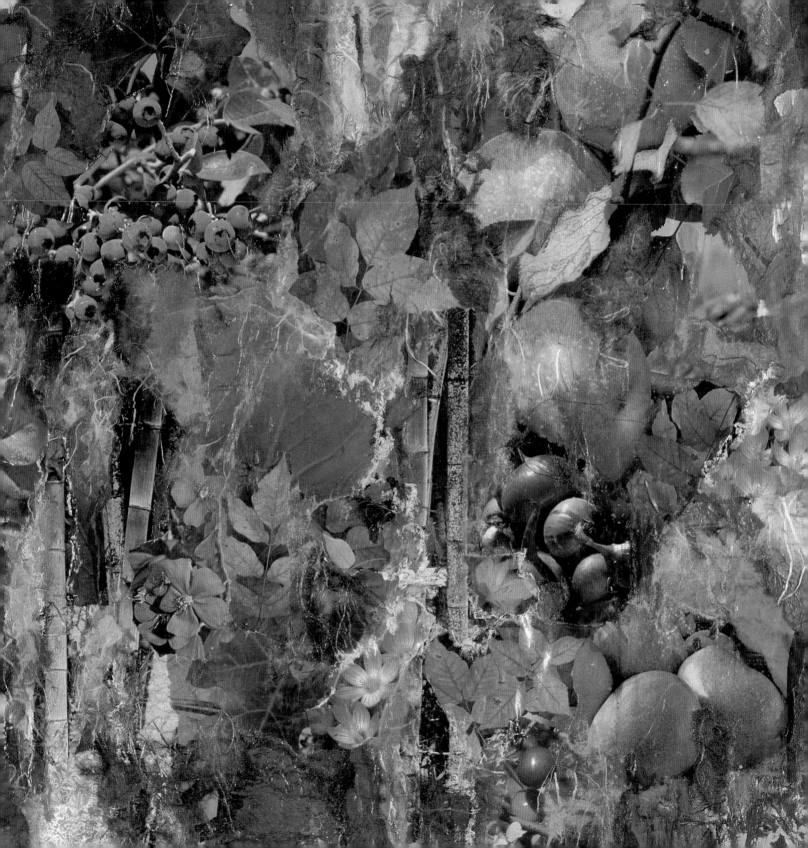

MONTAGE

When the dominant theme or material of a collage is photography, it is called a montage. The technique of application is no different than when using magazine photographs or color copies. Any subject can make a wonderful montage and photographs of family, friends, scenery, and animals are readily accessible. Combining photographs with other types of collage produces spectacular results.

For this piece, original photographs and photocopies were arranged chronologically. The simple bold mass of color running diagonally through the composition allows the viewer's eye to move around the many components. It also gives each photograph a relationship to the next, keeping the artwork from appearing too busy.

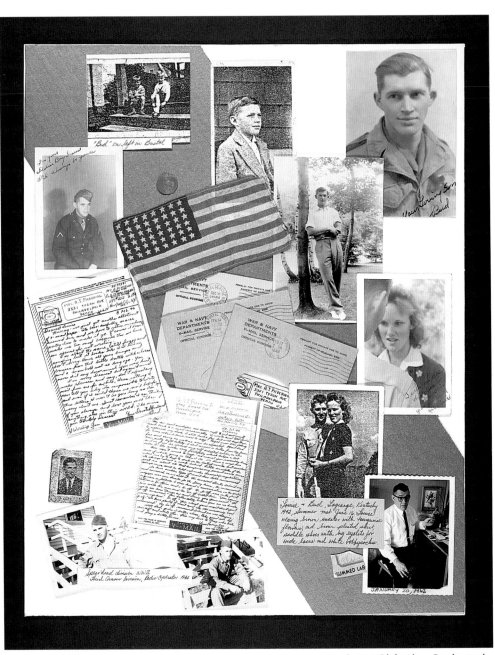

My Dad *16" x 20"* *Susan Pickering Rothamel*

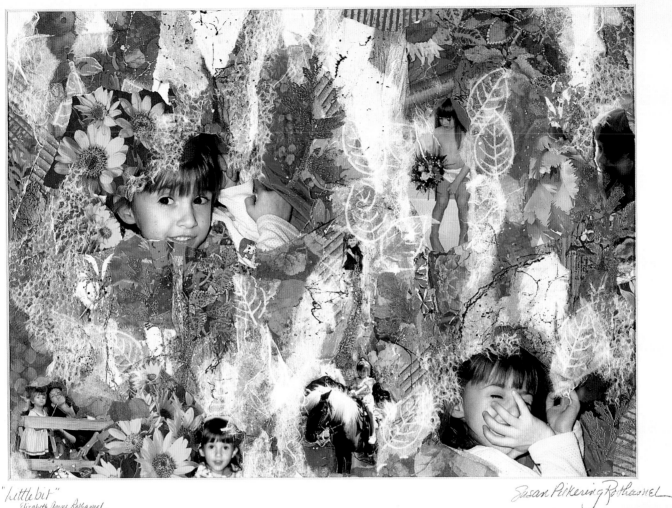

"Little Bit"
Elizabeth Anne Rothamel

Susan Pickering Rothamel

Little Bit 16" x 20"

Susan Pickering Rothamel

This montage painting was begun with a recycled collage. The floral theme was perfect for my granddaughter Elizabeth, who loves flowers. The color scheme worked well with the photography that was available. With the addition of several more layers of paper, touches of oil pastel, and a dash of metallic pigment mixed with PPA, the painting was complete. Photographs selected were cut and gently adhered with repositionable tape. Glossy pictures look best remaining glossy. Finish with matte adhesive on art papers and gloss adhesive on the photographs.

NONOBJECTIVE COLLAGE

Defined as art which does not represent any object, figure, or element in nature, nonobjective painting best illustrates the concepts of design, composition, balance, harmony, color, and space. Experimenting in this style of artistic expression can be an invaluable educational and introspective experience. As a jumping-off point for exploration, use paper and color to interpret a favorite passage of music, phrase, poetry, or prose. In the following example, a few words selected from a Bible passage were enough to inspire a whole series of paintings.

Materials needed:
- Adhesive
- Decorative art papers
- Glue container
- Magazine photographs
- Paintbrushes

Optional:
- Acrylic paints
- Assorted three-dimensional objects
- Dry pigment powders
- Embossing powder

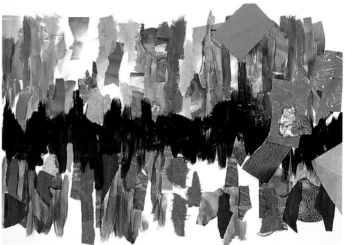

1 The inspirational passage found in Isaiah 54 refers directly to sapphires, topaz, beryl, and rubies. These jewel-like colors are selected to begin an underpainting and for the choice of papers. The passage refers to "Gates." Gates being rather vertical in appearance influence the patterning of color. The strong verticals are interrupted by a dark horizontal line running through the composition. At this point there is no rhyme or reason for the patterning other than an analogous coloring of the surface, and striking a harmonious balance between upper and lower halves of the painting.

2 With the underpainting complete, the addition of papers begins in earnest. Ignoring blatant compositional problems at this point is fine. A balance of color and patterning will come later with the addition of more papers.

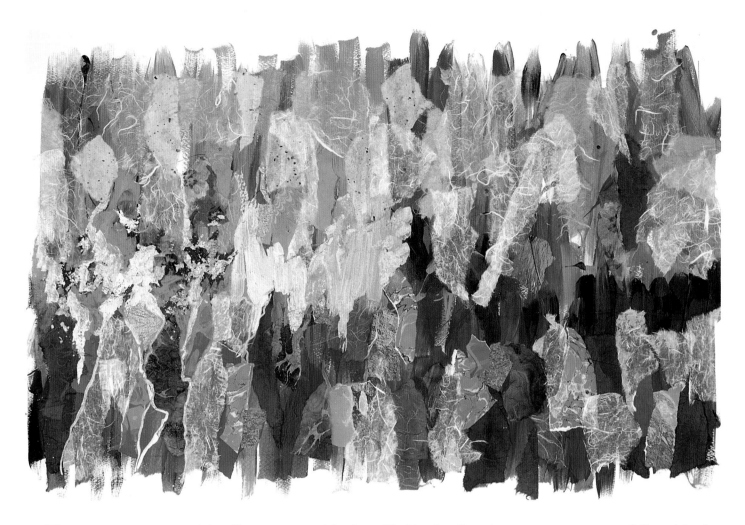

3 The painting is compositionally stronger with the papers added. The Oriental papers soften the harsh underpainting and still maintain the jewel-like quality. The dark line is now too dark. It is the first thing the viewer sees and it must be softened. When the embellishing touches are added to the edges and in-between the color changes, it is apparent that the dark line can be softened. In the completed artwork as seen on pages 52–53, the line integrates more gracefully with the painting. This is also achieved by changing the line to metallic gold. Adding gilded sticks reinforces the vertical planes, carrying the viewer's eye from the top to the bottom of the picture. The horizontal line carries the eye from side to side, allowing the viewer to stop and enjoy color passages along the way.

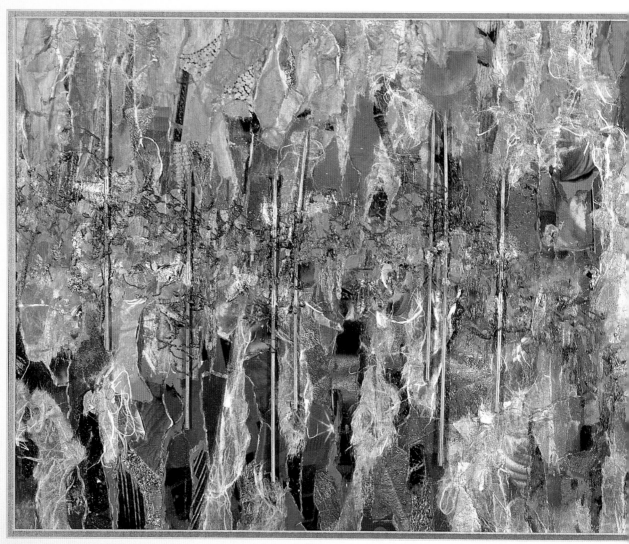

"Strength and Promise"
ISAIAH 54

52

Susan Pickering Rothamel

"*O thou afflicted, tossed with tempest, and not comforted, behold, I will lay thy stones with fair colours, and lay thy foundations with sapphires. And I will make thy windows of agates, and thy gates of carbuncles, and all thy borders of pleasant stones.*" *Isaiah 54:11–12*

Strength and Promise 23" x 35"

FIGURATIVE COLLAGE

Portraits and figurative art are among the oldest and most traditional of all art subject material. Figurative work in collage is very forgiving, so even a novice can produce some rather amazing results.

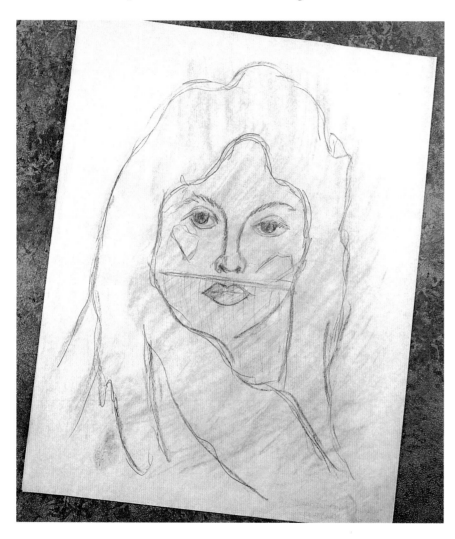

1 A rough sketch, using the willow stick charcoal on tracing paper, will help determine if the idea will be successful or not. This is the time to work out any compositional problems, such as placement of the figure.

Materials needed:
- Acrylic paints
- Adhesive
- Decorative art papers
- Magazine photographs
- Mixing tray
- Paintbrushes
- Studio cup
- Tissue or tracing paper
- Willow stick charcoal or graphite stick

Tips: In figurative collage, it is probably most important to use the mat liberally to determine compositional balance. Try it on the painting often.

If papers selected are not quite the right color, paint them with acrylic paint. This is also the time to make decorative paste papers and other textures for use in the figurative collage.

Be aware of possible color combinations. Value is the degree of lightness and darkness of a color running from light to dark. For example: pastel pink is the lightest value in the red scale, with burgundy being considered the darkest. Therefore, black and burgundy are similar in value.

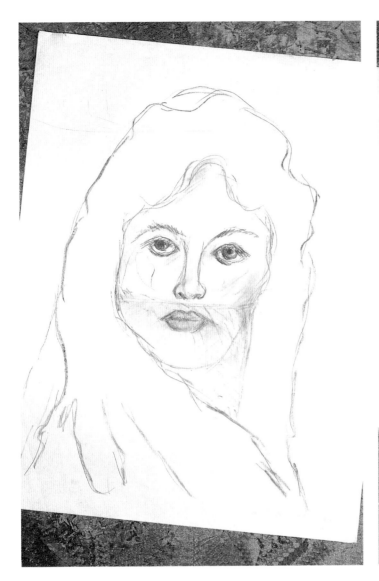

2 With a second piece of tracing paper, trace the figure drawn. The drawing should be identical to the original after all adjustments have been made.

3 Turn the second tracing over and scribble the back side with the willow stick charcoal.

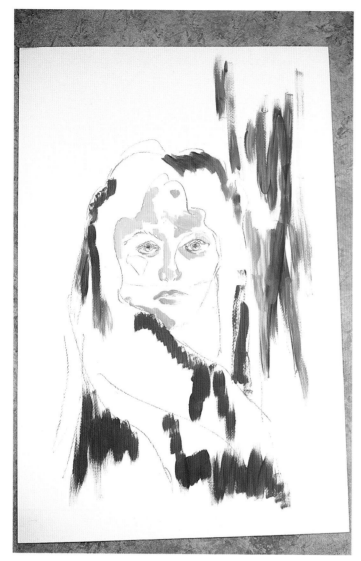

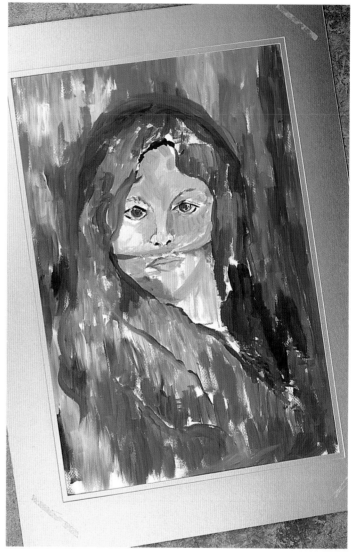

4 Place the tracing, scribble-side down onto the work surface, and retrace the drawing with a pencil. After the tracing is complete, begin the underpainting to determine values and color placement. Using acrylic paints for the underpainting will allow for many changes and further development of the composition.

5 Once the underpainting is complete, begin adhering papers. Develop the entire collage, adding papers and color from top to bottom and side to side. Continue to compare values and develop areas of contrast. As papers are added to painting, and the underpainting becomes more developed, delicate use of watercolor or acrylic paints can highlight or darken shadow areas.

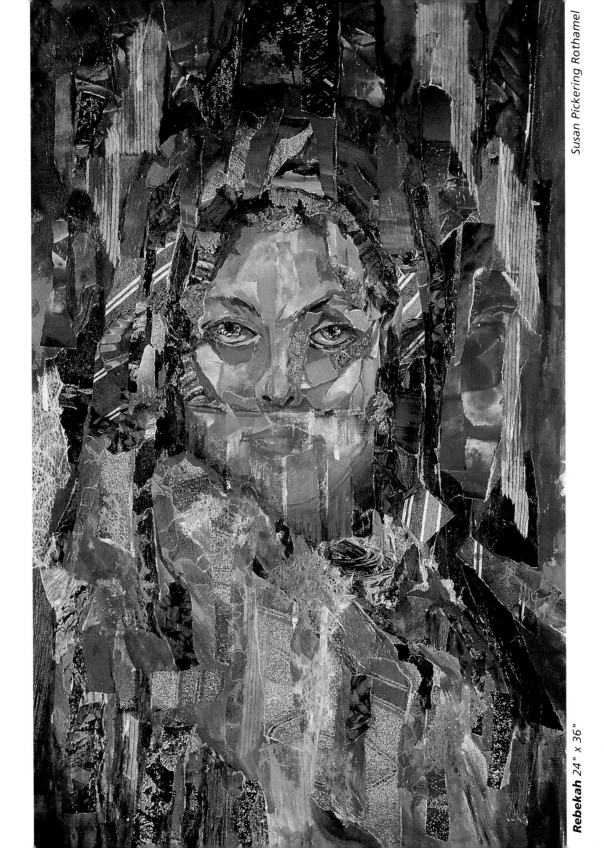

Rebekah 24" x 36"

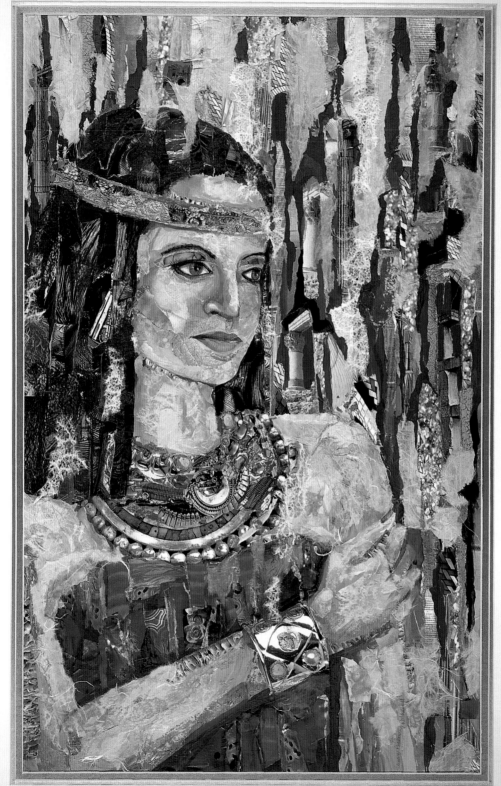

The Queen of Sheba

Susan Pickering Rothamel

Queen of Sheba

POCHOIR COLLAGE

Pochoir, (pronounced poosh-wahr) is similar to, yet unlike, traditional stenciling. Instead of painting in the negative image, pochoir techniques use the positive image. Rather than working within the confines of a cut-out form, pochoir paints the outer edges, leaving the shape of the cutout on the painting surface or collage papers. Although brushes can be used, it is especially ethereal when done with an airbrush or spray bottle. Not everyone has access to an airbrush, so spray paint or a paint-filled spray bottle can be substituted with this technique.

Materials needed:
- Spray bottle
- Stencils
- Water
- Watercolor or acrylic paints, thinned

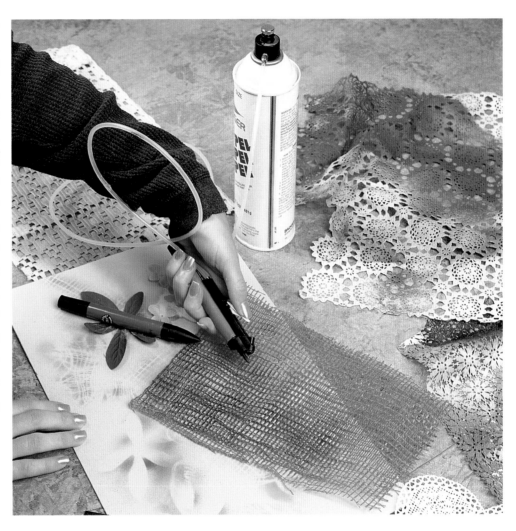

1 Select a background color in a neutral tone. This establishes the overall background color and eliminates unnecessary collage work. Several colors, using an airbrush system, were used to develop the base patterning for the collage. Note that other than the one silk leaf formation, the various patterns chosen were representative of shape and structure. They do not have to be indicative of the subject itself.

Tips: You can buy ready-made stencils, or you can make your own. Experiment with different materials, such as waxed paper, acetate, and thick, heavy-duty paper. Use scissors, a craft knife, templates, or your own patterns and images to achieve the desired effects. Flowers, feathers, old place mats, silk leaves, and fabric also make interesting forms.

If you are sensitive to sprays—pigments mixed with gum arabic and put into a spray bottle make a suitable spray paint that is nontoxic and odorless. Beware: this water-based background can run when adhesives are applied.

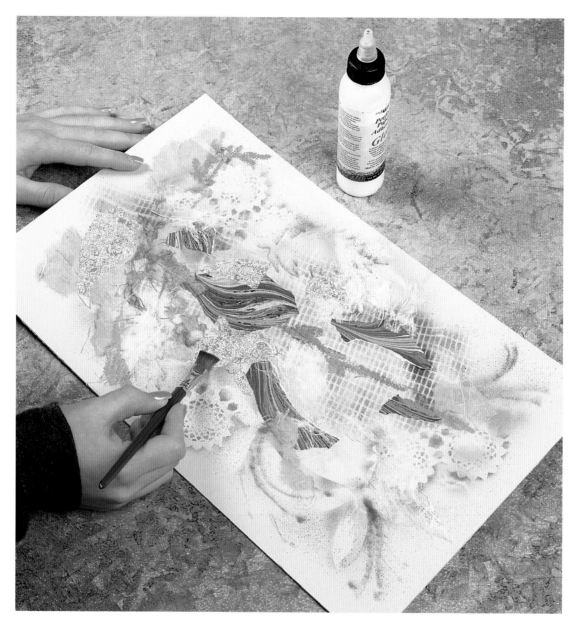

2 Additional pochoir effects are added and further color development is sprayed into place. Collaged papers begin to define the shape of the painting keeping the loose pochoir background. Work the entire painting using art papers, to define and redefine the subject. Details, using dry pigment and acrylic adhesive mixtures and oil pastels, are worked into the painting.

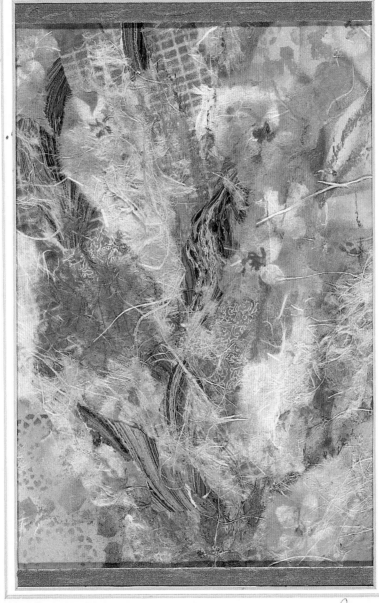

"*First Draft*" *Susan Pickering Rothamel*

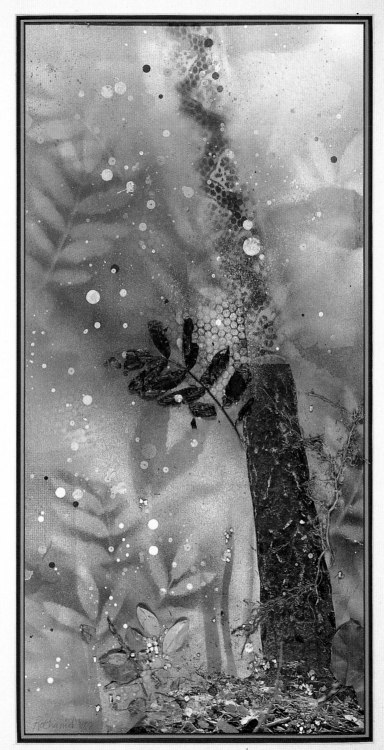

"IN MY OWN BACKYARD"

In My Own Backyard *17" x 20"*

PHOTO TRANSFER COLLAGE

Photocopy art (sometimes called xerography) is not new, but the manipulation and modification of these images through new types of equipment, such as color copiers, is becoming a widely embraced art form. With the photocopy technology constantly improving, many artists are taking advantage of this nontraditional art experience. One can experiment with image, pattern, and texture through the adjustment of quality, size, shape, and color. Photo transfer produces a rough, yet delicate, stained and almost transparent effect. The image is actually printed onto the paper, so there is no need for any adhesive.

Materials needed:
- Lacquer thinner or acetone
- Masking tape
- Photocopies of images (black-and-white or color)
- Scissors
- Spoon or burnishing tool
- Stiff paintbrush
- Watercolor paper

1 Cut the image to be transferred, leaving little tabs of paper hanging out for taping. Be certain edges and tabs are free of extraneous imagery which can be inadvertently transferred.

Place photocopy image face down onto paper. Keep in mind that the image will appear reversed. This is particularly important when using text. Use masking tape to secure it.

Caution: Lacquer thinner and acetone are dangerous substances. You must do this project in a WELL ventilated area.

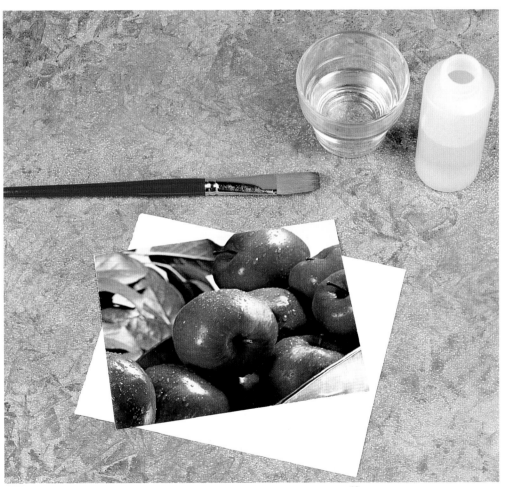

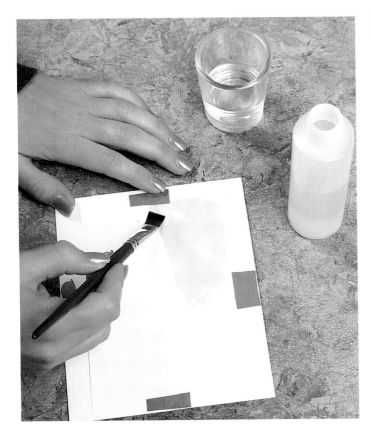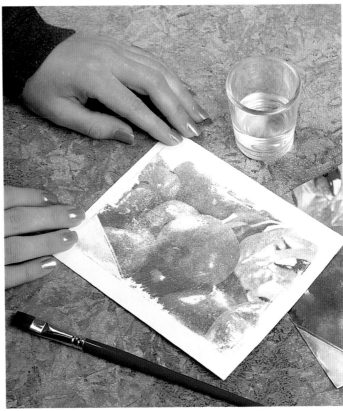

2 Pour out a small amount of the lacquer thinner or acetone into a glass jar or cup. This must be glass, because the thinner may melt a plastic container. Using a stiff brush, dip it into the thinner and brush a fairly generous (but not runny) amount onto the face down image, brushing back and forth. Do small sections at a time, because the thinner evaporates very quickly.

With a spoon or burnishing tool, immediately begin rubbing and burnishing the image onto the paper. Some pressure is needed, but be certain not to rip or damage the paper.

3 Continue spreading thinner over surface in small sections and burnishing until image is complete. Periodically lift and check image carefully to ensure a good transfer. Peel off paper and tape to reveal image.

Tip: This technique must be done using photocopies not originals. Most printers use ink, which will run and bleed when wet with the acetone or adhesives.

The addition of art paper and embellishments make photo-transfer collage an intriguing and pleasurable way to create art.

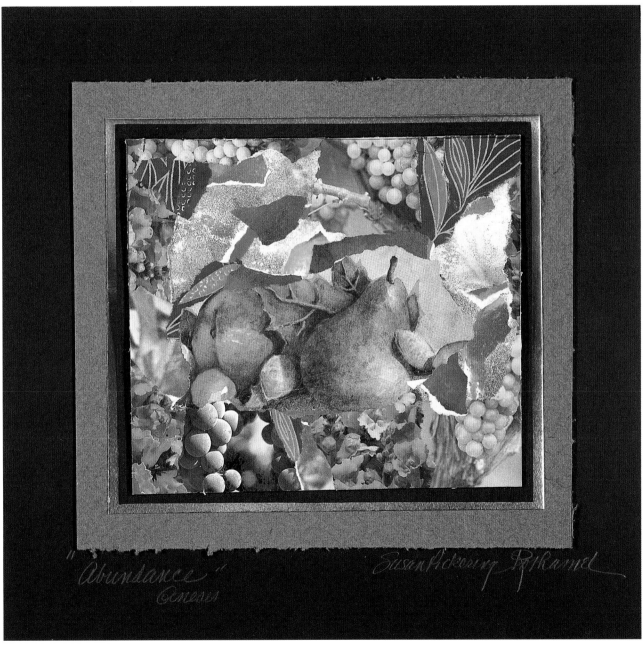

Abundance *11" x 11"*

Susan Pickering Rothamel

FAUX PASTE PAPER

This is an easy alternative to getting exciting, creative, and personalized decorated papers suitable for collage painting. Faux paste paper making is fast and fun. Ready-made paste papers can be very expensive and some methods, while incredibly beautiful and delicate, are very time-consuming with complicated formulas. If this easy method is an enjoyable experience, other traditional paste-paper-making recipes may be found in books at the local library.

Materials needed:
- Acrylic paints
- Perfect Paper Adhesive™, gloss or matte
- Assorted embellishments: mica, glitter, spray finishes
- Assorted texturing devices: sponges, combs, springs, sticks, card stock, marbled papers, magazine photographs, or color copies
- Dry pigments
- Rubber stamps (optional)
- Soft, wide paintbrush
- Studio cups for mixing colors

1 For the best results and patterning, coat paper with a thin film of adhesive. Let dry. This makes paper less absorbent. The object is to keep the color on top of the paper long enough to create patterns. Matte or gloss adhesive can be used for this process.

Mix several colors of dry pigment into adhesive. PPA makes an excellent medium for pigments. The gloss adhesive is particularly good when mixing metallic pigments. Liberally apply pigmented adhesive or acrylic paints to paper. Pull combs, springs, or other tools through color. Let dry.

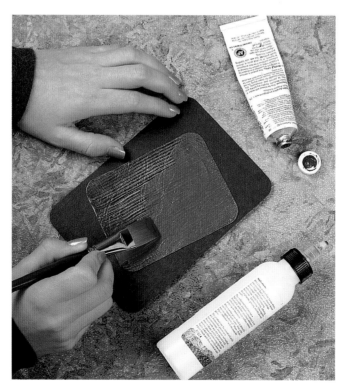

2 Liberally brush a second (and third, if necessary) coat of paint onto patterned paper.

Note: Stamping into and onto paste paper will give two results. Dry, stamping creates a pattern onto the combed paper. Wet, stamping lifts color from the paper, creating yet another type of pattern.

Immediately wash the stamps when used, so that the acrylic paints and pigmented adhesive will not dry onto the rubber.

A plastic coffee can lid or the side of a milk container, cut with decorative-edged paper trimmers, makes an excellent texturing tool.

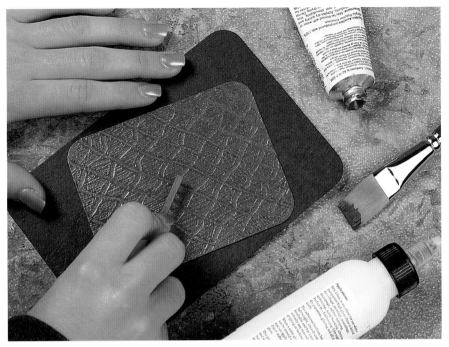

3 Using a different tool or rubber stamp creates additional patterns.

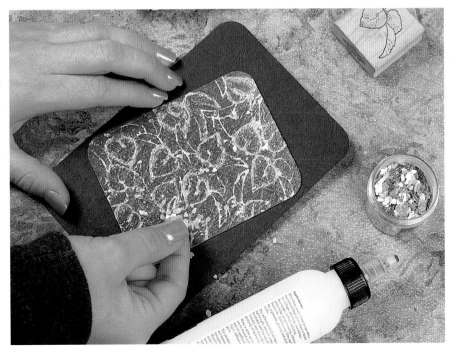

4 Once dry, several colors and textures can be layered. Embellishments will adhere to wet pigment because the base is adhesive.

PASTE PAPER SAMPLER
Artists - Left to Right:
Gayle Burkins
Terry Daniels
Susan Pickering Rothamel
Kay Crandall
Sandra McCall
Red Scott
Sandra McCall
Toni McCorkle
Susan Pickering Rothamel

Faux-lace Embellishing Border

For years picture framers have used double-sided, repositionable tape for archival matting and framing. Artists are now discovering its diversity as a unique art material. It can be used with an automatic transfer gun or simply by tearing and applying it with your fingers. This technique is ideal for borders, mats, decorative edging, and embellishing within the collage painting.

Materials needed:
- Double-sided, repositionable tape
- Embossing powder
- Heat tool
- Mica flakes, granules, or powder (mica is heat-resistant)

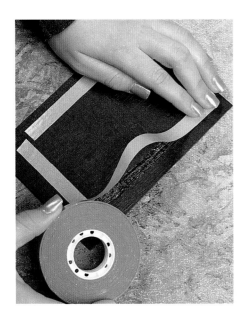 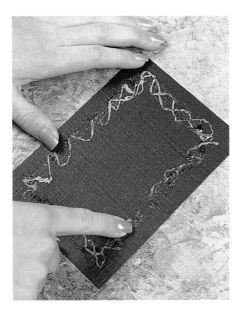 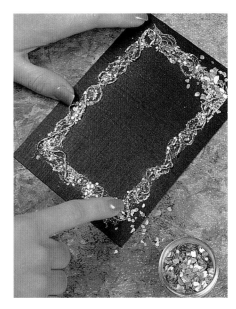

1 Lay strips of tape on desired area. Peel off the paper liner.

2 Use fingers or both thumbs to gently roll the sticky adhesive in opposite directions simultaneously. It will roll into lacy patterning. If rubbed too hard the adhesive will come right off.

3 Remove long strips of tape from roll and twist slightly. Lay in lacy patterns on top of ruffled row. Sprinkle mica onto sticky areas. With one or several colors of embossing powder, sprinkle over, under, and around tape surface. Tap off excess and heat-emboss.

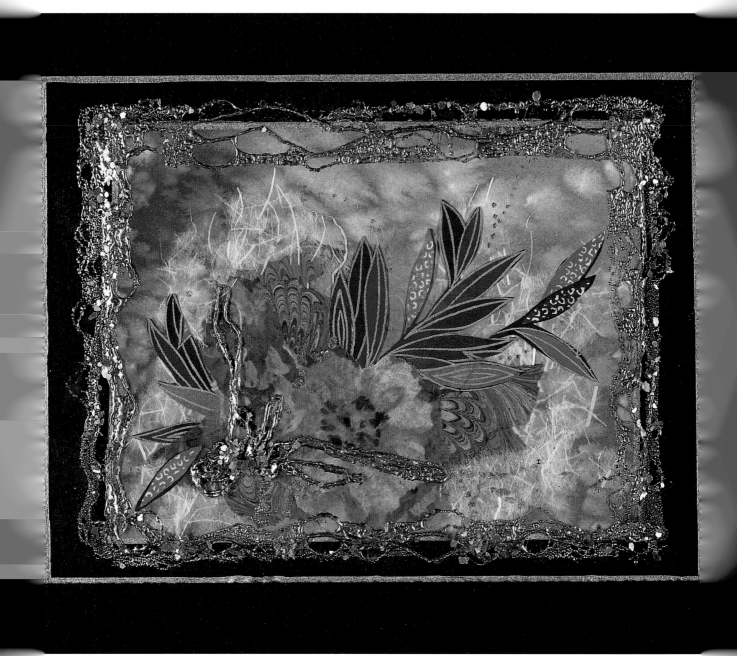

aters 6" x 8"

Susan Pickering

Bordering and embellishing can enhance even a simple collage.

COLLAGING THE MAT

There are many different styles, shapes, colors, and textures of mats from which to choose. Why not make your own? Collage is not only for the art itself, but can also be used for the frame. By experimenting with different collage techniques and various heights of the mat itself, very diverse effects can be achieved.

Tip: Whatever the shape, it may be helpful to use the piece that was first cut as a template. Simply put the piece with the cut-out opening on top of the next piece to be cut, trace opening, and cut.

Materials needed:
• Adhesive
• Assorted art papers
• Craft knife
• Embellishments
• Foam-core board
• Hot glue
• Metal straightedge
• Ruler

1 Cut one or more pieces of the foam-core board. By cutting several and stacking them one atop the other, any height can be made. This is important if the artwork that is being framed is dimensional. Cutting the board is tricky, use a metal straightedge and a sharp craft knife. Measure in from the edge, allowing an opening large enough for the artwork to fit inside. This area will be cut out and become the frame. Cut all of the pieces with identical openings. When all the pieces are cut, stack and adhere them together with hot glue.

71

2 When finished, there will be one unit of foamcore board, consisting of three individual pieces adhered together. Do not be concerned about superficial marks or dents. They will be covered when the frame is collaged. It is simpler to start at the inside edges and adhere torn bits of paper, before bringing the paper up onto the top surface. Adhere other

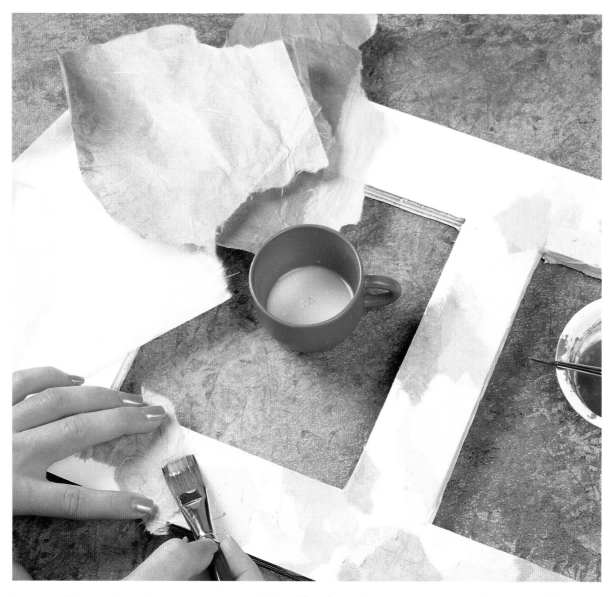

small bits to the top. When dry, the mat can be embellished further, using markers, watercolors, acrylic paints, and mica flakes.

Tip: Bleach can be used to change the color of papers. Black papers will often turn yellow or green. A dusty rose-colored paper was dipped in very diluted bleach and rinsed thoroughly to produce the peachy-orange color used in this collage.

The three-dimensional collaged mat adds pattern and texture to this assemblage. Found objects such as metal, beads, paper, plastic, and other interesting bits and pieces were assembled to become icon representations. Handmade paper with mica flakes makes the perfect backdrop for contemporary imagery.

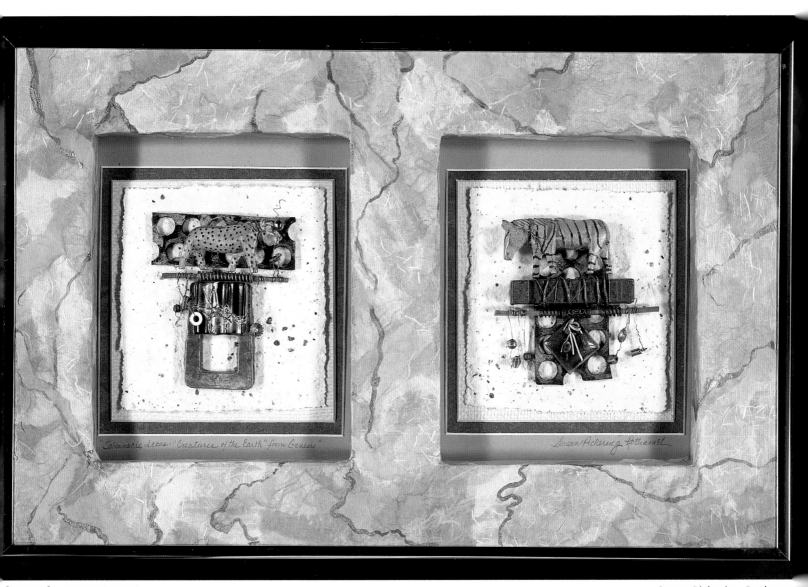

bernacle Icons *12" x 19"*

Susan Pickering Rothame

IMPRESSION LIFTS COLLAGE

This technique yields an unusual image which duplicates the original picture, but resembles a transparent stained glass window. Used alone, or even sandwiched into a large piece of mica, or other transparent surfaces, impression lifts can be a colorful and unique paper-like addition to any collage.

Materials needed:
- Acrylic adhesive—gloss or gel medium gloss
- Magazine photograph or color copy of any image
- Paintbrush

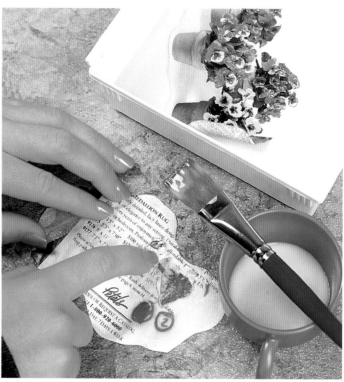

1 Select any magazine photograph or a color copy of any picture. Using a soft brush, apply a heavy but even coat of acrylic adhesive. Let dry. It may take several hours (up to 24 hours), depending on the humidity levels or which medium was used.

Tip: Clear acetate can be substituted for the paper. No soaking is needed as the image will peel relatively cleanly from the acetate.

2 When completely dry, place the image into a shallow dish of warm water. Let it soak for a few minutes, Very gently remove the paper from the back of the adhesive. Carefully rub off the paper backing. Take care not to stretch the "lift", unless the image is to be deliberately abstracted. The water softens dried medium, producing a very stretchy surface.

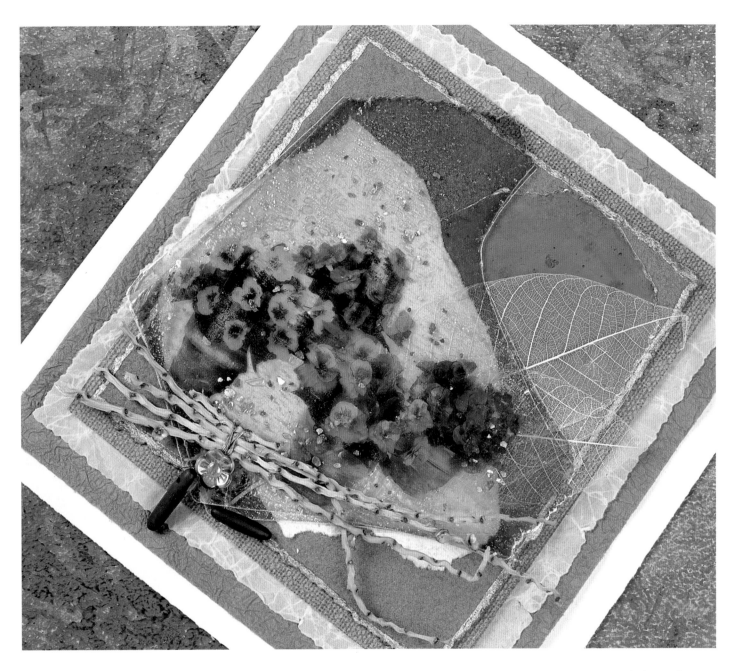

3 Trim finished "lift" by cutting or tearing. The transparent image can be put onto any colored, handmade, or textured paper. Experiment with different backgrounds, images, and applications. This one was mounted on several layers of papers and skeleton leaves. Beads and wire-wrapped twigs add just the right touch to the naturalistic mica and floral lift.

PAPER CASTING & COLLAGE

Paper casting is as simple or as complicated as one wants to make it. Ready-made moulds are available for decorative casting. However, for an original hand-cast piece suitable for collage painting, all that is necessary is a simple picture frame and some three-dimensional bits of oddities that are water resistant. This easy method makes a surface ideal for dimensional collage art.

Materials needed:

- Adhesive
- Cotton linter (or recycled papers, blended smoothly in a blender)
- Mould
- Sponge
- Towel
- Water
- Water tub

Optional:

- Adhesive-back metal foil tape
- Assorted decorative papers
- Dry or wet pigment
- Mica-flakes, granules, and powders
- Oil pastels
- Polymer clay pieces, buttons, jewelry, shells, etc.

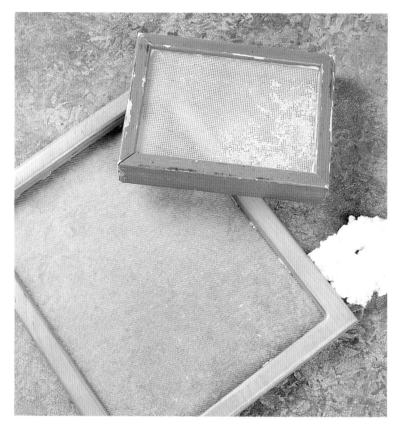

Tips: Plastic screen or plastic canvas adhered to the inside bottom of an old picture frame with hot glue is a simple and effective casting mould. A paper-making screen or stretcher bars with screen can also be used instead of the frame.

Many mould shapes can be created, using household items, such as plastic candy containers, microwave dishes, and more. Punch holes in the bottom of solid containers so that water can run out.

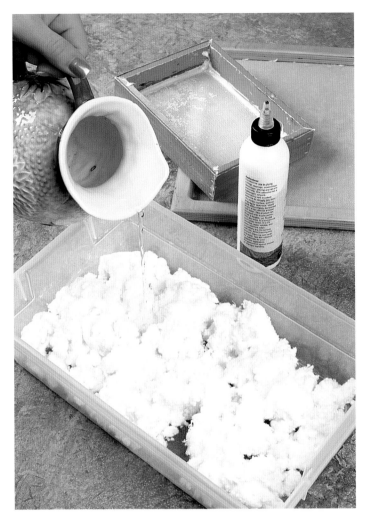

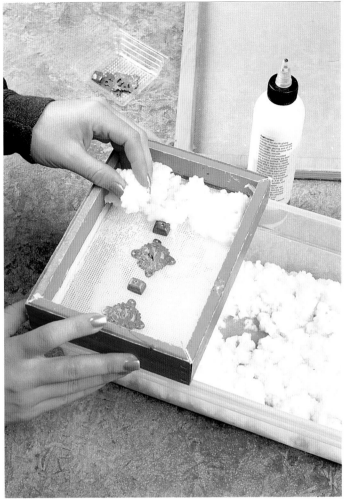

1 Place the cotton linter into the tub and add just enough water for the linter to get slushy. The linter will absorb water and disintegrate, forming the paper pulp. Add a squirt of adhesive for sizing. This will help hold the fragile linter paper together when it is dry. Now is the time to add pigment if a base color is desired.

2 Place the dimensional pieces onto the screen, right side down. Gently add pulp. Hold the frame over the tub to catch the draining excess water. Continue adding pulp until the desired thickness is reached. Use the sponge to press out the excess water between each addition of pulp. Let dry. The drying process could take several days, depending on the thickness of the paper.

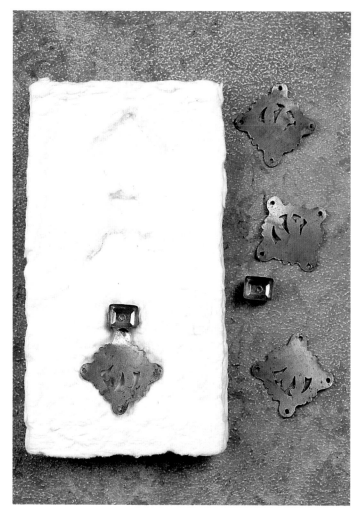

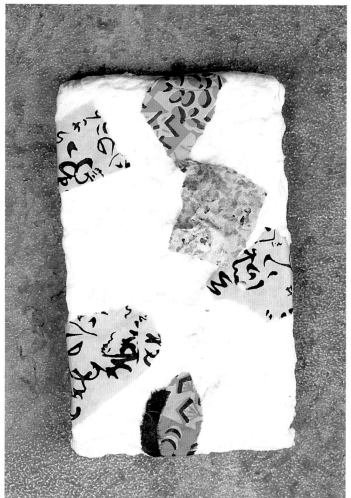

3 Remove the dimensional pieces during the collaging process. Continue to work them into place now and then to assure a close fit.

4 Adhere art papers, paste papers, and other decorative papers randomly to the casting. Proceed in this manner until piece is complete. Highlight and embellish with various mixed-media materials. Use the appropriate adhesive to place the dimensional pieces into the artwork.

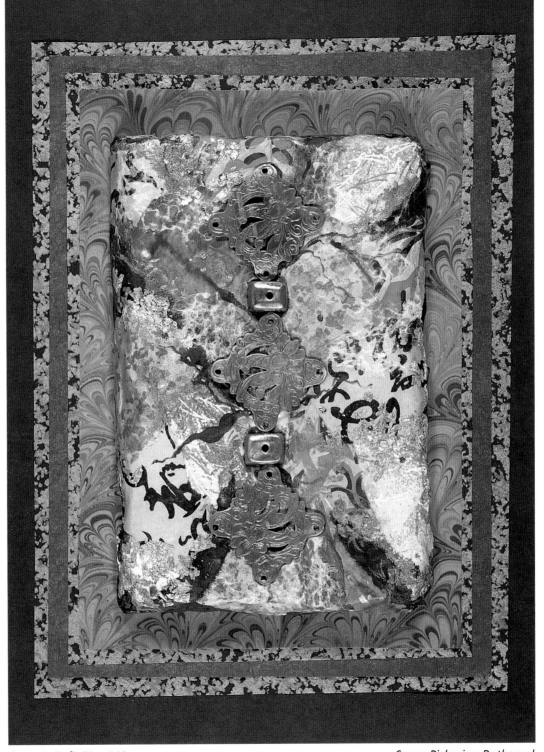

Jesse's Belt *8" x 11"* *Susan Pickering Rothamel*

1 Adhere art papers, paste papers, and other decorative papers randomly to the casting. Proceed in this manner until piece is complete.

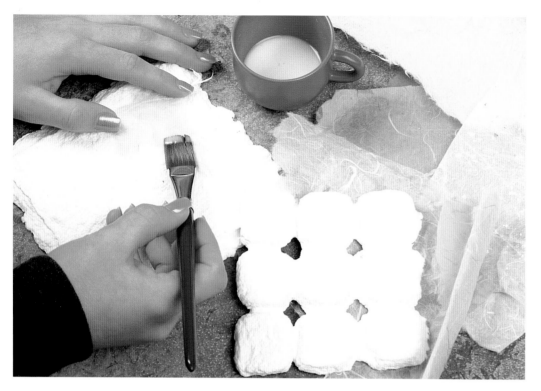

2 Highlight and embellish with various mixed-media materials. Use the appropriate adhesive to place dimensional pieces into the artwork.

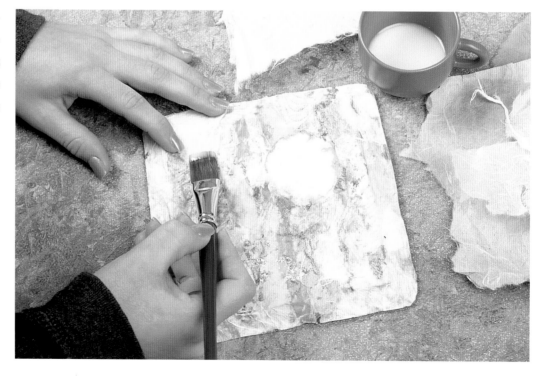

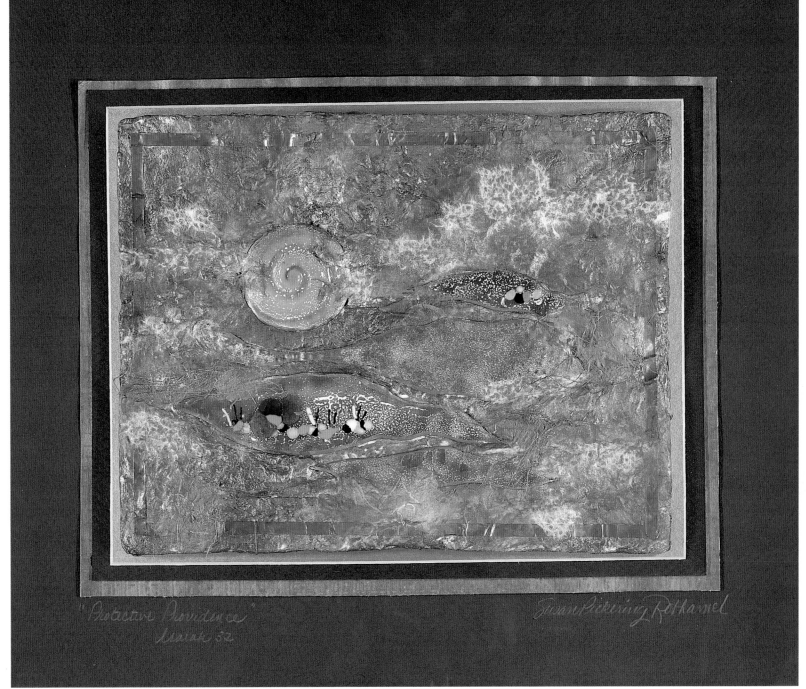

Protective Providence 16" 20"

Susan Pickering Rothamel

"And my people shall dwell in a peaceable habitation, and in sure dwellings, and in quiet resting places; When it shall hail, coming down on the forest; and the city shall be low in a low place. Blessed are ye that sow beside all waters, that send forth thither the feet of the ox and the ass." Isaiah 32:18–20

RECYCLED PAINTINGS & COLLAGE

Sometimes creativity strikes when the least amount of time is available to really explore a new subject. This is the time to drag out all of those "less than successful" watercolors, collages, and even oil paintings. There are almost certain to be entire paintings or small areas of paintings that can be recycled into exciting new works of art.

Materials needed:

- Adhesive
- Assorted art papers
- Mat board or watercolor paper
- Obsolete artwork

1 This older collage had colors and patterns that were strong. But, as a whole, the painting just did not "work." Smaller pieces, cut from the original, will make several starts for new artwork.

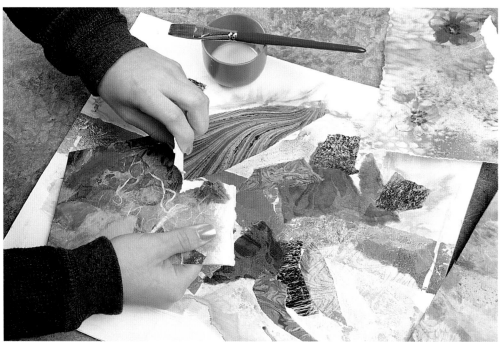

2 Subtle strokes of pastel and the addition of a few papers make this a good example of recycling and salvaging from a larger collage painting.

Morning Lily 10"x 16"

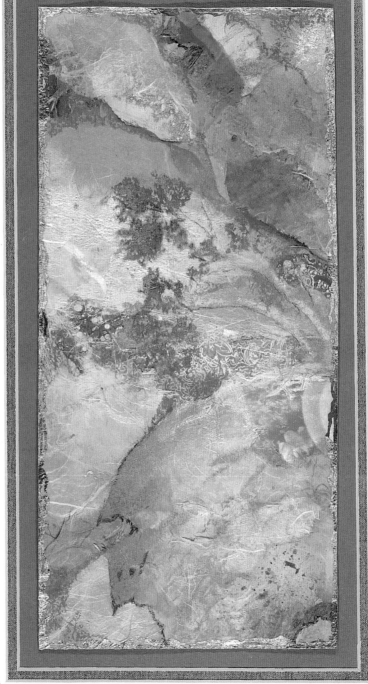

"Morning Lily"

Susan Pickering Rothamel

MAIL ART COLLAGE

An art form, begun by artists wanting to exhibit their artwork apart from the routine gallery or museum walls, mail art is now an international movement. Created in the '60s and gaining momentum, due to the influence of the rubber stamping industry, its original intent was to create possibilities for artists to communicate different ideas and information by sending art to one another. Ordinarily based on a single theme, there are no limitations in media or in technique. Generally speaking, mail art is usually two-dimensional and mail-ready. There has been much experimentation with various media, such as stamping, audio, video, painting, drawing, postcards, and, of course, collage.

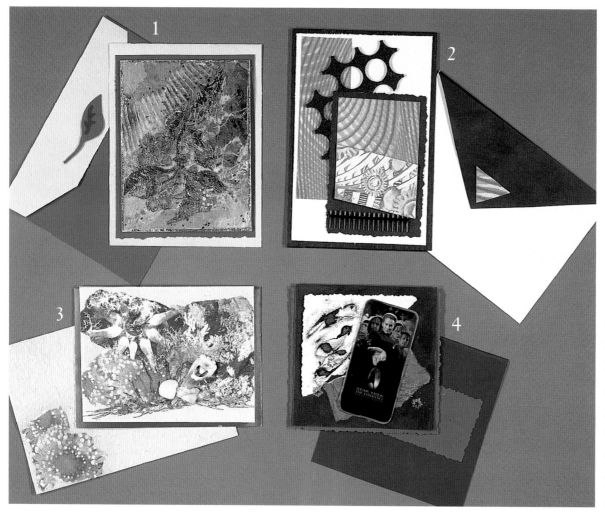

1—Recycled collage & rubber stamping
2—Paste papers & found objects
3—Color copy transfer & shells
4—Marble paper & found object

BOOK ART COLLAGE

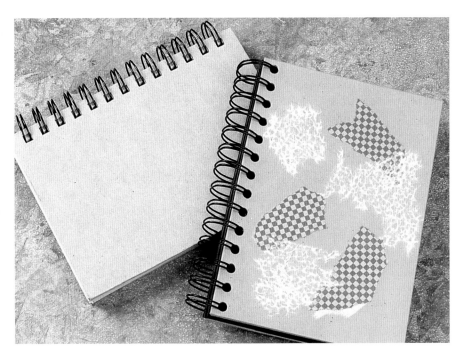

1 Begin by adding torn pieces of art and lace papers to the cover of a plain blank book. Tear the papers randomly for a soft deckle-like edge.

2 More colored papers were added for contrast, pattern, and texture.

A form of self expression, the book arts are as old as antiquity. The current popularity can be attributed to a resurgence in journal making, photograph albums, scrapbooking, storybook making, memory albums, and more. However, because the book arts can integrate such a vast number of media, ranging from the metal arts to polymer clay, glass, found objects, and the humble piece of paper, many are rediscovering the simple joy of making a book. Not only are there a myriad of interesting and creative methods for designing bindings, latches, covers, and pages, there are the endless possibilities of colors, shapes, and sizes.

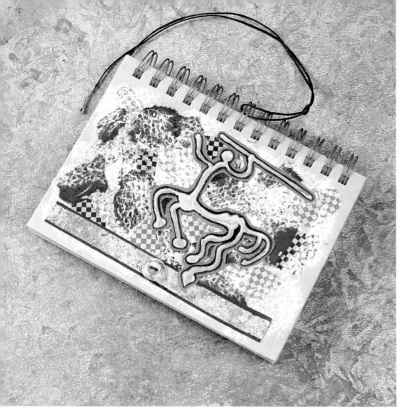

Sketch Journal *5" x 7"* *Lori Mason*

3 To finish, a touch of gilding leaf was placed along the edge of the book. A small button and a piece of cord add an interesting closure. A small, abstract figure was drawn in black and gold and adhered on top of the papers.

4 Inside the book, sketches, notes, and painting exercises add personal touches.

Art Continuum Catalog

concept—Ginny Carter
artists—Gayle Burkins & Pam Sussman
interior pages stamped, found objects inserted, printed, hand-manipulated

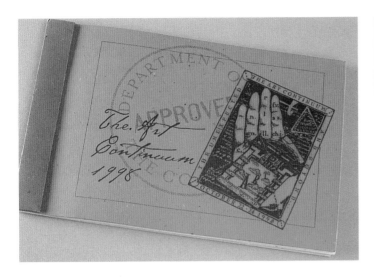

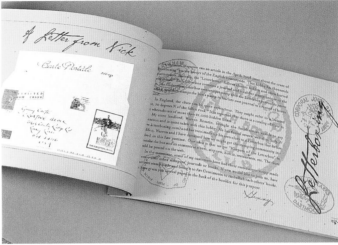

This catalog was done on a word processor. It was stamped, hand-manipulated, handbound, and includes many found objects.

Text was superimposed over another enlarged rubber stamp. Mail art was incorporated into the catalog, which was handbound.

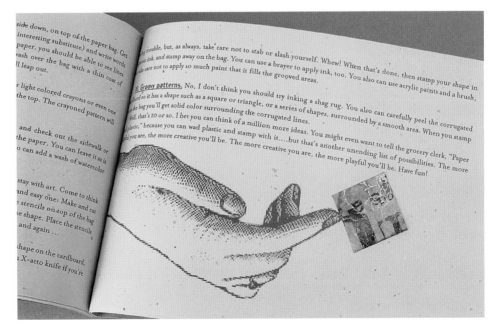

A rubber stamp image was enlarged and reproduced with a small, colored inserted detail.

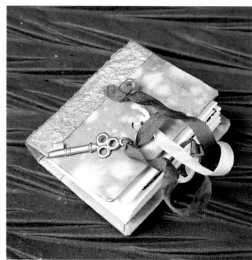

Pin Book *1½" x 2"* *Donna Kazee*

The interior pages of this charming book/pin were collaged, hand-stamped, accordion folded, and then attached to the front and back inside covers. Ribbons, with tiny key attached, are tied in a bow to make the closure.

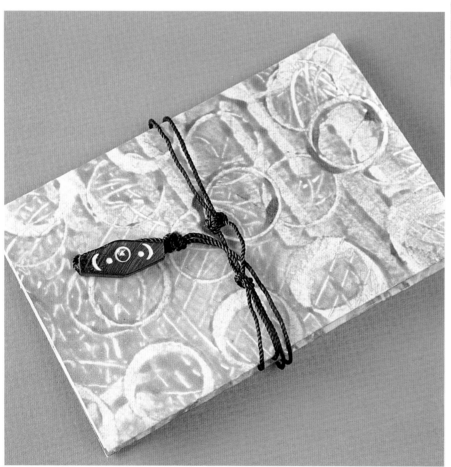

Paste Paper Booklet *3"x 5"* *Karen Strunk*

This small blank book contains a single signature on the inside, while the outside is paste paper made from the traditional cooking method. The pattern was made using a round metal cap.

88

Unique Collage Making Materials

Some embellishments, like webbing spray, are familiar products in the craft industry and have only recently been discovered as viable mixed-media additions to fine art and paper collage. Have fun and experiment with all the new materials available.

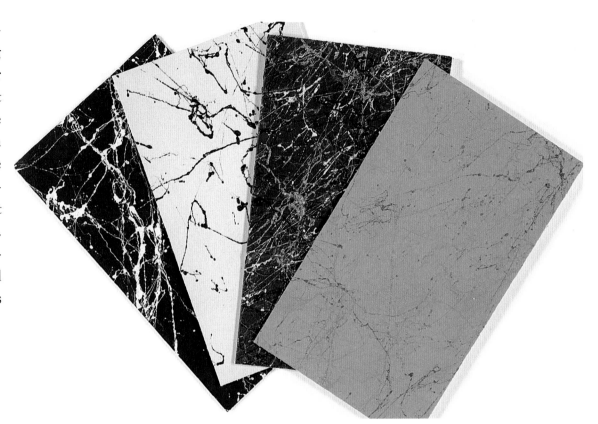

WEBBING SPRAY

This diverse product can be used on almost any surface, including paper, mat board, wood, clothing, furniture, frames, and more. Webbing spray creates a marvelous abstract web pattern useful in the creation of decorative papers and collage painting. Read the label for application and use in a well-ventilated area only.

First practice spraying on scrap paper to get a feel for it. The beauty of this paint is that the lightest touch creates the most abstraction. Hold the can about 18" from the surface and spray in a quick sweeping motion. Rotate the working surface and spray again. Spray into the air, with surface directly under where paint falls.

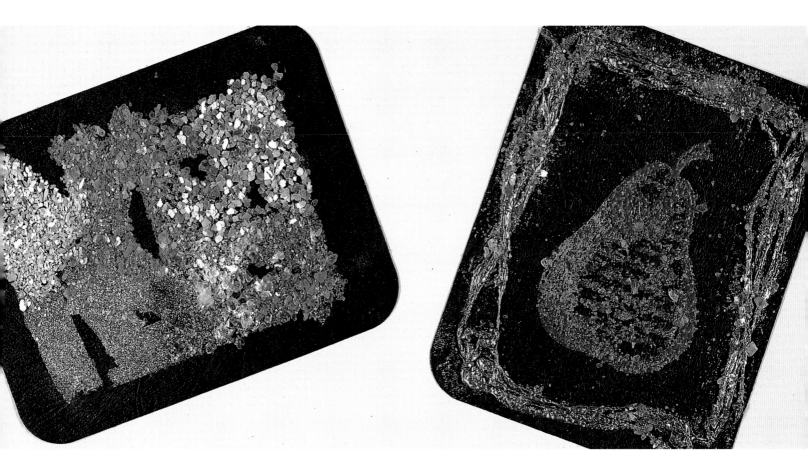

MICA FLAKES & GRANULES

Small bits of mica have a myriad of uses. Consider using them for any medium such as oil, acrylic, watercolor, collage, paper making, rubber stamping, and all arts and crafts. They are archival, acid-free, and lightfast. They work with almost any adhesive, double-sided tape, embossing powders, encased in embossing tiles, and under practically any finish, such as varnish and glazes.

Use mica flakes and powders in embossing. Sprinkle it on top of the embossing powder and heat-emboss. Mica can be used to accent and highlight any artwork. Use it in painting and all types of collage.

CRACKLE MEDIUM

This medium creates an antique and aged effect. When applied between two coats of acrylic paint, it produces antique-looking cracks onto the surface. The bottom color layer will show through the top color layer. It is best used on wood, paper, metal, plaster, and other hard surfaces. This can create marvelous effects for backgrounds. Using bits and pieces of paper with this crackle effect in collage and other artwork can add interesting textures. Experiment with different colors of acrylic paint. Try contrasting, monochromatic, and other color schemes. When heavily applied, the medium produces large cracks. When lightly applied, the medium produces very small cracks.

MICA-BASED DRY POWDERED PIGMENTS

Mica-based dry pigments can be incorporated into any viscous medium, such as paint, varnish, glue, or adhesive, to produce a pearlescent or metallic luster. They can also be applied dry, then sealed or dusted on top of a tacky surface. These pigments are ideal for exterior and interior applications because they are archival and colorfast. Experiment, using pigment particles both wet and dry. This can be added to gum arabic and water to produce a watercolor, or added to an acrylic medium to make an acrylic paint.

GLITTER SPRAY

This unique spray can be used on many art and craft surfaces, including paper, fabric, plastic, and wood. It produces a shimmering effect with lots of sparkle that is perfect for use in backgrounds and highlights. Read the label for application and use in a well-ventilated area only. Experiment with different colors and surfaces. The glitter in the spray is very small. When sprayed, the effect is subtle and powder-like. Try incorporating the spray into all arts and crafts, such as collage, painting, scrapbooks, greeting cards, and three-dimensional art.

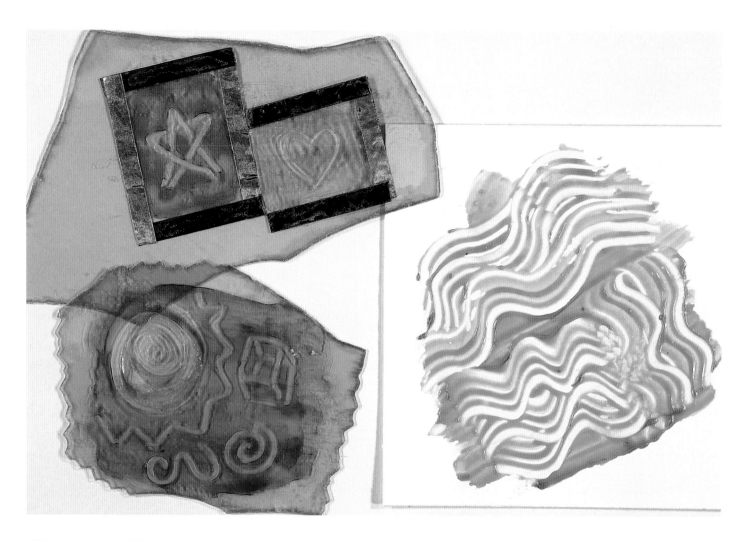

CRYSTAL GEL

This very thick gel produces interesting textured effects. Applying a layer of gel and using different texturing tools, such as combs, wood, and simple rubber stamps, produces a textured finish. It comes in many different colors, and works on paper, glass, plastic, wood, metal, and clay. This gel produces stained glass effects on transparent surfaces, such as glass, acrylic sheets, and mica. Experiment with thick and thin applications. Try drawing, combing, and scraping into gel after application before it dries.

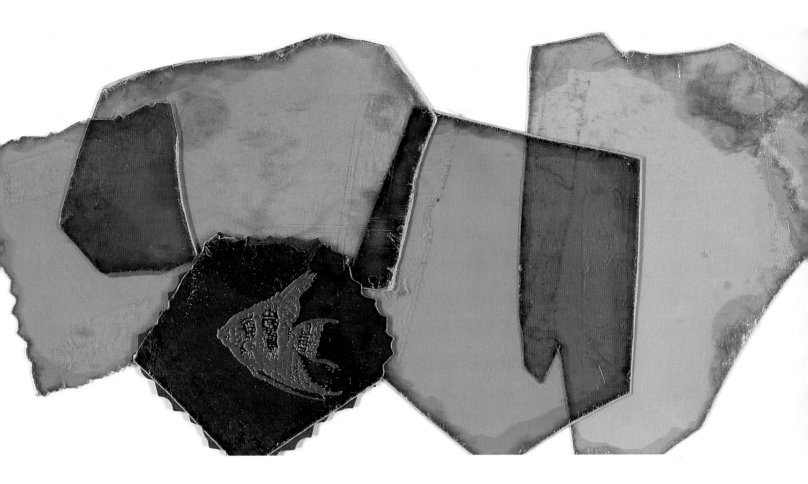

MICA TILES

These are large sheets of natural mica. They are smooth, transparent, and come in many sizes, ranging from large, flat pieces to smaller, more opaque pieces. Mica is heat-resistant, which makes it perfect for embossing uses. It can be split into thin sheets and reassembled for laminating effects. Since mica is transparent, try putting assorted images or objects, such as flowers, collage, and photographs, under and between them. Mica is sometimes called embossing tiles, and they cut easily with scissors and paper trimmers.

Stacking, breaking, and cutting mica pieces produce different effects.

Try this: Split a piece into two sheets (notice the mirror image). Heat-emboss a stamped image onto lower piece. Replace top piece and secure edges with an adhesive or a self-adhesive metal foil all around edges.

Try using clear embossing powder on one piece before sealing, then heat-emboss to permanently seal two pieces together. Use needle-nose pliers to protect hands from intense heat generated from the heat tool.

Artists' Gallery

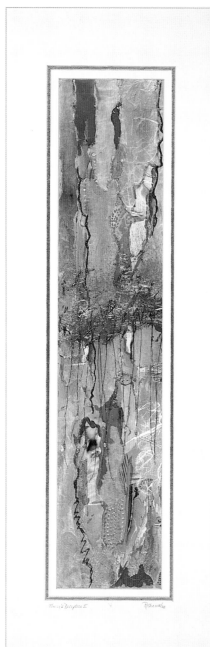

Susan Pickering Rothamel

Tamar's Deception II 9" x 31"

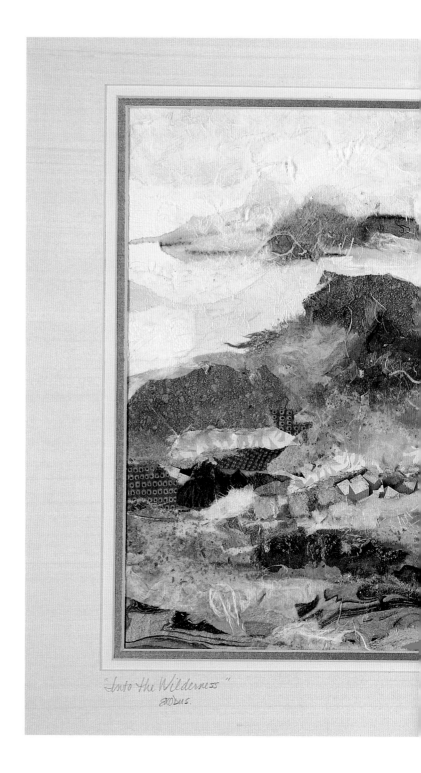

"Into the Wilderness"
EXODUS.

Into the Wilderness 20" x 32"

Susan Pickering Rothamel

ANNE BAGBY

Anne, from a small town in Tennessee, has enjoyed experimenting with art for the past 20 years. Married, and mother of two children, Anne began making art in her mid 30's focusing mainly on watercolors. Although she experimented with oil painting, she now works mainly in acrylics and the combination of acrylics and mixed media. Many of her pieces are small, individual, nonobjective paintings that convey a distinctive quilt-like design once the individual elements are assembled as one piece.

Inspiration for these collage works came from the LaVelle Vineyards in Oregon and use wine as a symbol of "celebration and hospitality."

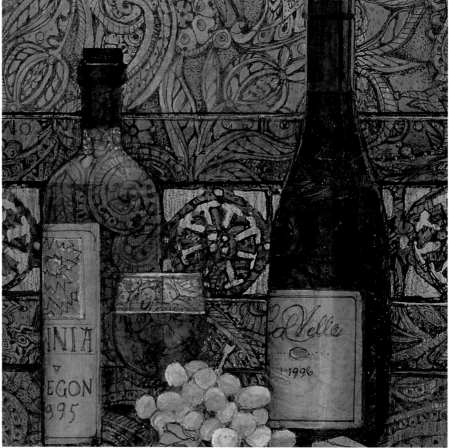

LaVelle - The small scale of this piece represents the detailed and complex style that is consistent throughout the entire "LaVelle" series. Assorted papers create many different textures and surfaces. Rubber stamping and acrylic paints add the embellishments to this collage.

LaVelle *7" x 7"*

Anne Bagby

Paper Whites - *A border of adhered tissue paper and rubber stamping surrounds the traditional composition of this still-life collage. Additional rice papers, dripped paint, and colored pencil create a texture that shows through the painting and collage.*

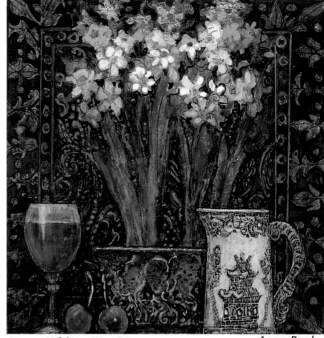

Paper Whites *7" x 7"* *Anne Bagby*

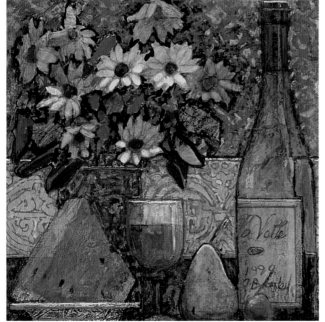

Picnic *7" x 7"* *Anne Bagby*

Picnic - *A textured surface is created by adhering wrinkled tissue paper to a stiff board. Concepts of traditional composition were incorporated into this mixed-media collage. The flowers, wine bottle, and glass are highlighted with acrylic paints and colored pencils.*

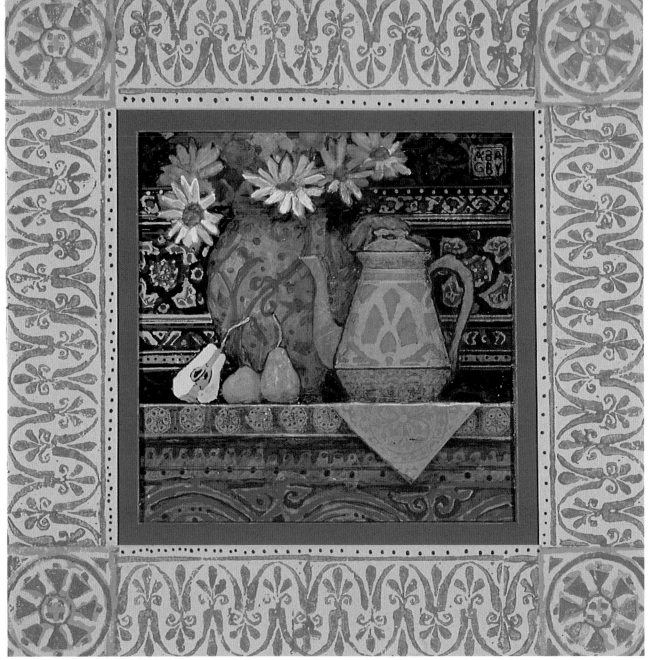

Country Still Life *7" x 7"*

Anne Bagby

Country Still Life - *The same textured surface is used to create the background for this collage painting. Assorted rice papers were added for various textural effects. Rubber stamping was used to create an intricate, almost lace-like pattern.*

Liz Burchill

Liz, now retired from the printing and publishing field, moved from the traditionally historic area of Bucks County, PA, to the wide-open spaces of Sun City West, AZ. The move, as well as her background in the trade, translates to art that is traditional in form, but contemporary and inspiring in design. Devoting much of her time to the arts, including interior design, ceramics, and painting, she uses watercolor, acrylics, and copper enamels to express ideas of color and balance. "However, collage gives me great freedom to explore color, balance, and texture with the medium commonly used throughout my career—paper."

Eve's Garden - Beginning with a simple sketch, using a bold marker on watercolor board, layers of transparent papers were gently attached to the surface. By wrinkling and allowing the papers to float freely, with only minimal attaching, textural surface design is greatly enhanced. Figures and forms are drawn and painted, and then added to the surface as a final layer. All the while, layered underdrawings radiate through the ethereal papers.

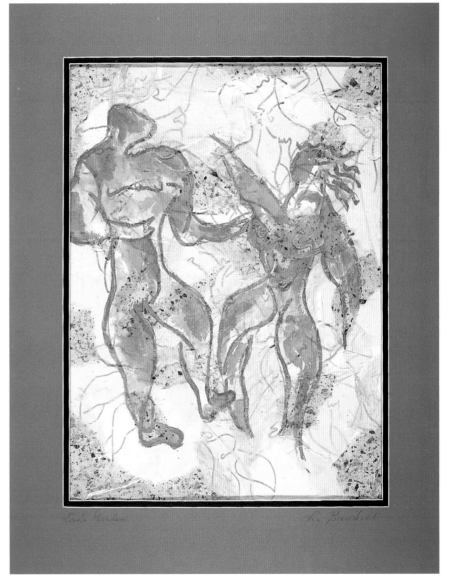

Eve's Garden 17" x 21" Louise Burchill

Anna Ely

Anna, a self-taught artist, lives and works in Florida. Turning to art as a way to escape the everyday stresses of life, this mother of three chose mixed-media art as her prescription to investigative introspection. Anna's main focus is on the paper arts, book arts, and collage. Instinctively, Anna selects materials for her collage pieces scavenged from yard sales, swap meets, flea markets, and scrap piles from industrial recycling. Anna's art is shown in many paper art publications and at local art galleries.

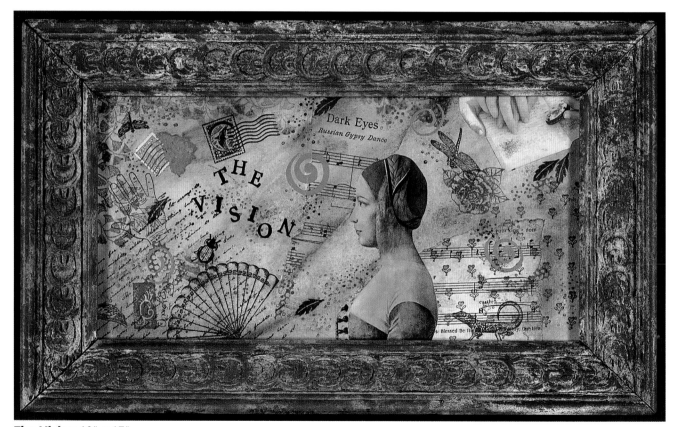

The Vision *10" x 17"*

Anna Ely

The Vision - *Various found objects, magazine pictures, and sheet music were used for this collage. Scattered stamped patterns play across the surface. Paint and stain give an aged appearance. An integral part of the actual collage is the antique frame, which has a faux finish.*

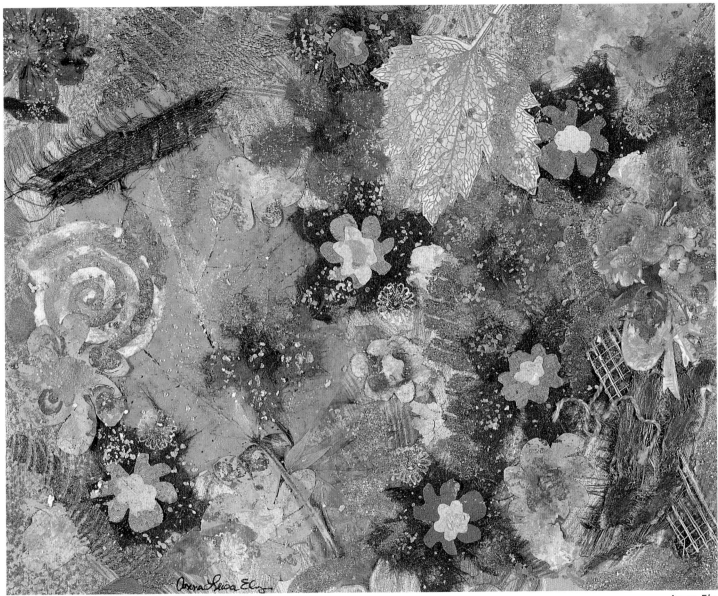

Floral Study *8" x 10"'*

Anna Ely

Floral Study - *Floral cutouts made from decorative papers, leaves, and leaf images are integrated and layered in this piece. The textured and varied surface is created from string, embossing powder, and bits of colored mica. Bees and flowers dance unconstrained through the layers of floral imagery.*

Heartstrings Box - *This collage began with a plain mahogany box that was painted. Sheet music, foreign stamps, and labels adhered to the box top, were then painted and stained with metallic paints. Creatures and greenery were rubber stamped onto the wood. Little details of text and pattern unify the design.*

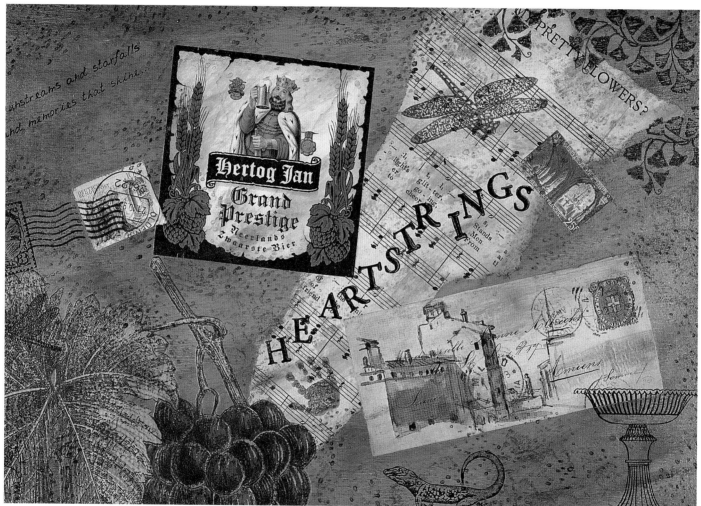

Heartstrings Box *12" x 8" x 2"*

Anna Ely

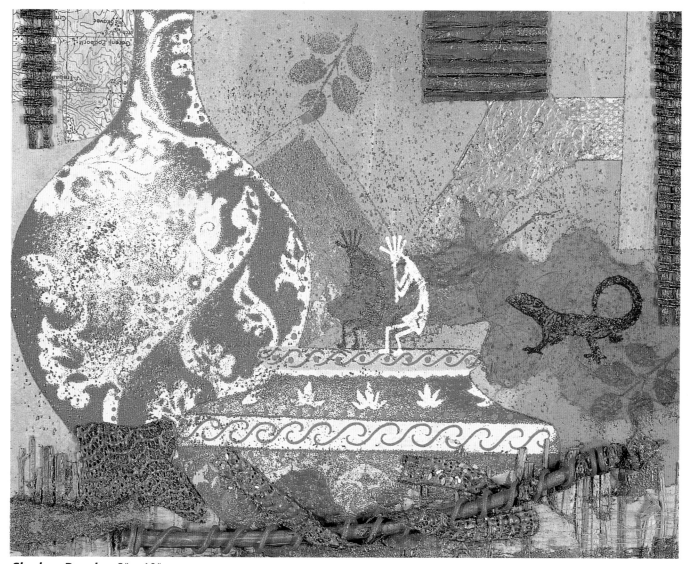

Shadow Dancing *8" x 10"*

Anna Ely

Shadow Dancing - *Large cutouts of pottery, small scraps of art papers, and even the tiniest piece of map are the background for this collage. Stamping and embossing are used to create representational imagery. Painted sticks and wood pieces are adhered to the surface. The result is an undulating landscape of pattern and texture.*

JEANNE HALEY

Involved in the arts for the past 25 years, Jeanne indulges herself and her art by collecting extraordinary found objects, scraps, and miscellaneous paper ephemera. Creating collage by the liberal use of rubber stamps, paper, and odd bits of this and that, her work has an offbeat attitude. Her interest in collage and mixed media was sparked while making puzzle books for her daughters. Jeanne is inspired by her surroundings, the Sierra Nevada Foothills of California.

Ticket to Ride - *Beginning with a stretched and gessoed canvas, a collection of tickets, tags, and paper oddments were sorted by color, style, and design. The layered pattern effect and gradation of color insinuates a unique quilt-like image.*

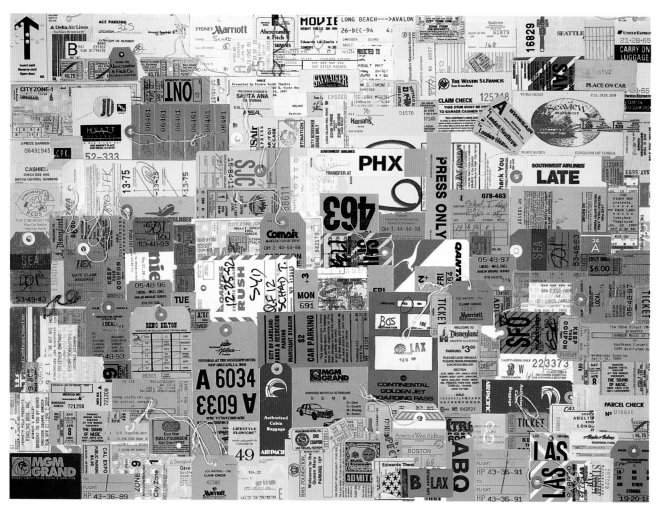

Ticket to Ride 22" x 30"

Jeanne Haley

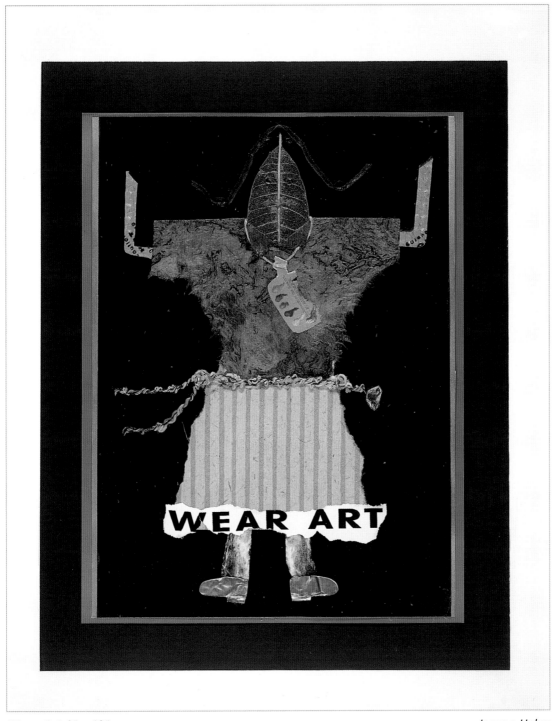

Wear Art - *A curious grouping of materials form the basis for this charming piece. Copper bits, an old tag, leaf skeletons, yarn, corrugated cardboard, and fine art papers are used to allow the viewer to ponder the necessity of the statement to "Wear Art".*

Wear Art *9" x 12"*

Jeanne Haley

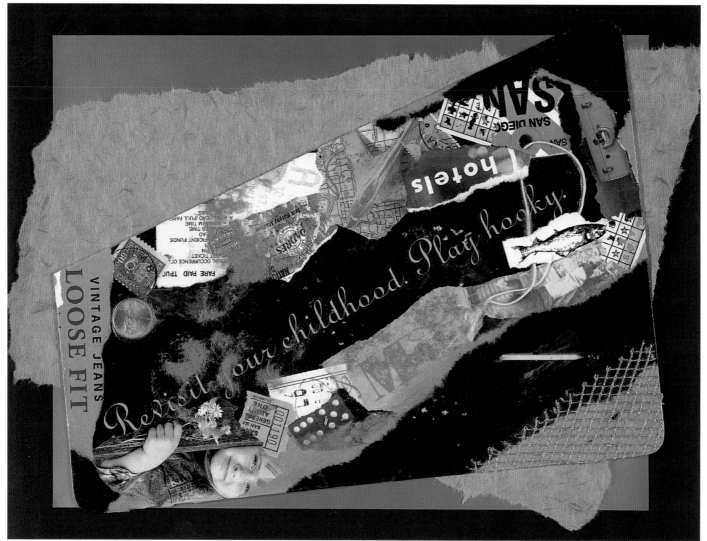

Revisit Your Childhood *9" x 12"*

Jeanne Haley

Revisit Your Childhood - Much like "Wear Art", it is the odd assortment of materials that creates the story of this piece. Note in particular the penny, the match, fishing paraphernalia, ticket stubs, and flowers, all of which can express recollections of youth that are thoughtfully reminiscent of a more simple time.

JANET HOFACKER

Janet, a self-taught artist, uses collage as a way to convey feelings and emotions. Collage source material is found in city streets, junk stores, and trash cans. Leading into unexpected places, the collages are continually altered and reworked.

With influences from collage and assemblage artist, Kurt Schwitters, she believes that they share a passion for found materials. She enjoys drawing and doodling, as well as making fabulous art journals. Delighting in sharing her gift with others, magazines have regularly sought out her inspired work for publication.

Series - *"The numerous alterations and reworking of a subject include sanding, tearing, peeling, painting, staining, and dying the papers. A collage can seem never done! However, this attention to alteration and detail, makes my style of artwork appear old, distressed and weather beaten. Adding three-dimensional effects and texture, using modeling pastes, structural paints, wax, and cloth, enhance and strengthen the form and texture of my collage work."*

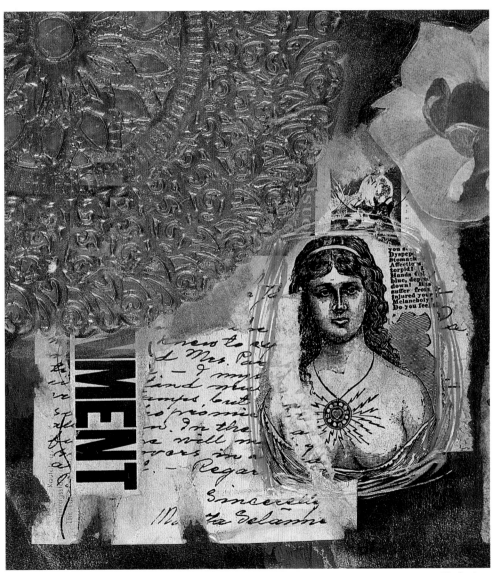

Series *8" x 8"* *Janet Hofacker*

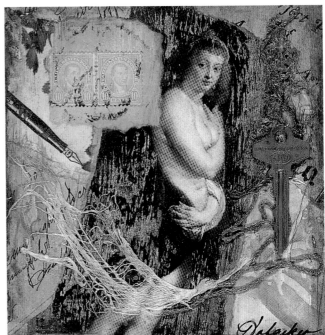

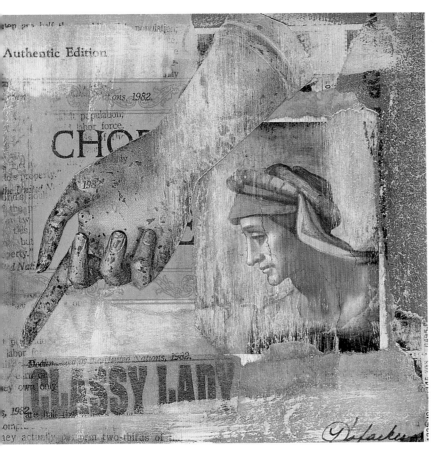

Series *8" x 8"* *Janet Hofacker*

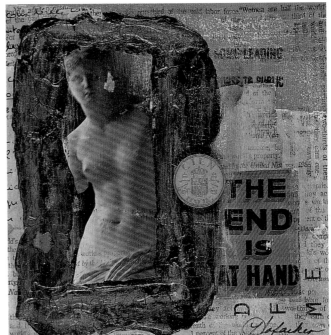

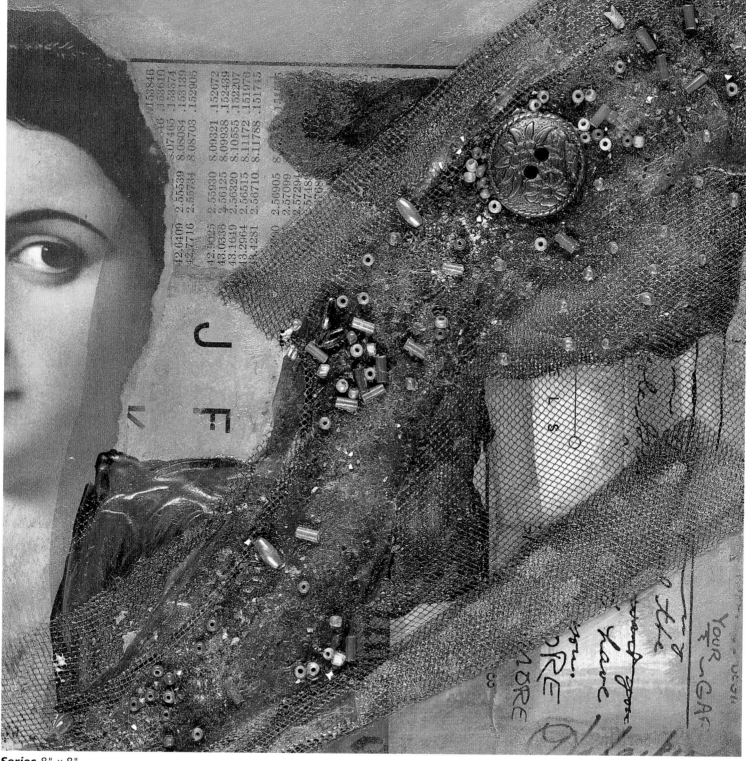

Series *8" x 8"*

Janet Hofacker

CATHERINE JANSEN

Combining traditional garden delights and cyber technology, Catherine's art captures the essence of floral collage painting. Working experimentally and in many mediums, Catherine is a professor at Bucks County Community College in Newtown, PA. She has been awarded numerous grants and has had many exhibitions. The Philadelphia Museum of Art and the High Museum of Honolulu, HI, are but two of several museums that exhibit her work.

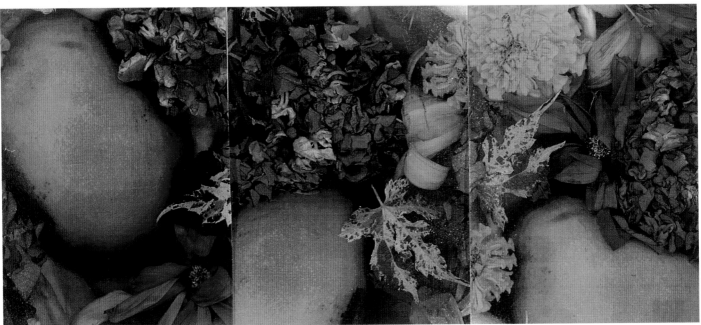

From the Garden-Series

Catherine Jansen

From the Garden - *"The flowers used in this series of paintings hold a great deal of meaning to me. Given to me by friends or family, and drawing from my own garden of blooms as well, the selection of flowers becomes symbolic of the bond and personal connection."*

The flowers, fragments, and leaves are carefully arranged onto the bed of a high-resolution scanner. Great attention is paid to the detail of composition, color, and balance. Once copied, using transfer paper, the images are color-copied onto rag watercolor paper. This creates a collaged look that captures both realism in nature and distinctive abstract form.

From the Garden-Series *Catherine Jansen*

From the Garden-Series *Catherine Jansen*

EDEE JOPPICH

Whether in her Farmington, MI, studio or on one of many excursions to faraway places, Edee creates vivid and colorful art wherever she lands.

Organizing group trips, she has taken artists to paint on location in places such as Italy, Belize, Mexico, and Spain. Traveling is very important for her work. The relaxed atmosphere is conducive to being open creatively and interpreting exotic locations into art. More charming than exotic, her gallery and artist retreats in northern Michigan are popular creative experiences.

Twenty-eight one-person exhibitions, inclusion in more than one hundred exhibits, as well as exhibiting in traveling shows to prestigious museums and galleries has definitely made Edee a successful artist in the public sense. She has been a watercolor instructor at the Visual Arts Association of Livonia in Michigan since 1978, and enjoys jurying exhibits and teaching various workshops.

Ancient Wallscape - *Using photographs from trips to Italy inspired this collage. Then came the integration of them into the actual design. Using various papers, magazine pictures, and even lint to create a surreal landscape, this is monochromatic painting full of pattern.*

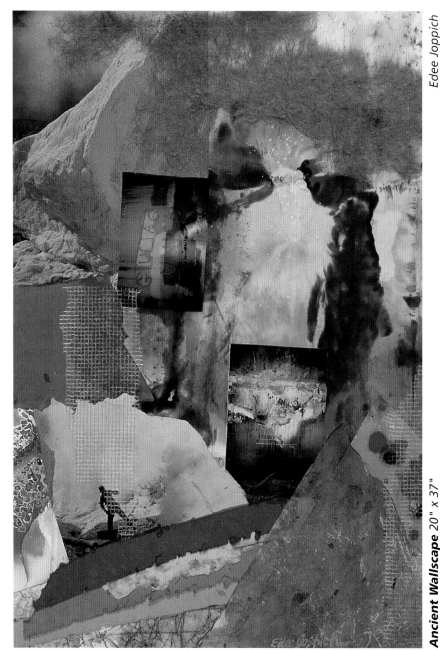

Edee Joppich

Ancient Wallscape 20" x 37"

Troubled Waters - Color-copied pictures taken from old slides make up the majority of this collage. Patterned rice paper was used to represent turbulent waters and handmade paper shapes add a unity to the entire piece. The story behind this piece is a mystery to the viewers, who are allowed to form their own interpretation of this multilayered collage.

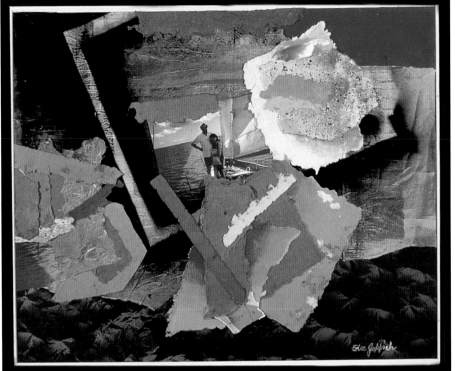

Edee Joppich

Troubled Waters *33" x 40"*

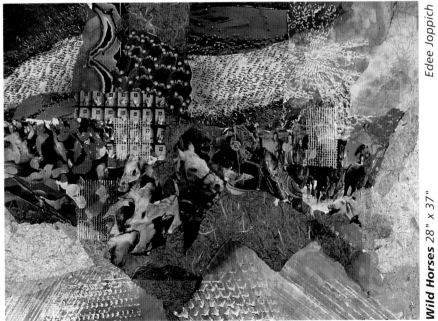

Edee Joppich

Wild Horses *28" x 37"*

Wild Horses - This complicated and intricate collage began with wax rubbings on a variety of raised surfaces, then painted with watercolor. This created very textured effects. Strong monochromatically, it displays the repetition of subject matter, color, texture, and pattern.

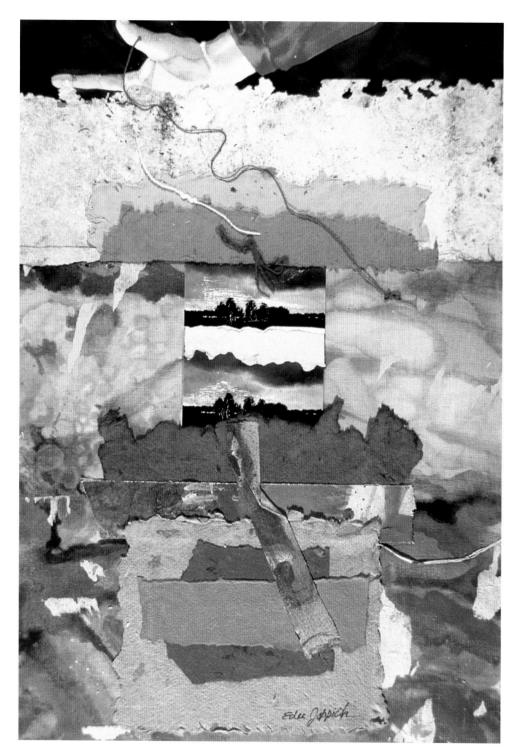

No Strings 27" x 36"

Edee Joppich

No Strings - Made with various papers, torn and stained canvas, as well as photographs, this collage unfolds into a pleasing composition. Initially begun with no preconceived ideas, subjects came from the studio. An image of a cropped hand, and an arm that was being used for a recent watercolor, is transformed into a newly created artwork.

Lori Mason

An emerging artist at 23, Lori has graduated from Siena Heights University in Michigan with a Bachelors degree in Fine Arts. She focused mainly on painting and drawing, with intense interests in collage and book arts.

Originally from Ann Arbor, Lori has been interested in art since she was very young. Her childhood is a strong theme in many of her pieces. "My art has always been about personal discovery. I am constantly trying to uncover hidden bits and pieces of a very fractured and turbulent childhood." In her free time, she enjoys visiting family and friends, reading, music, and of course, making art.

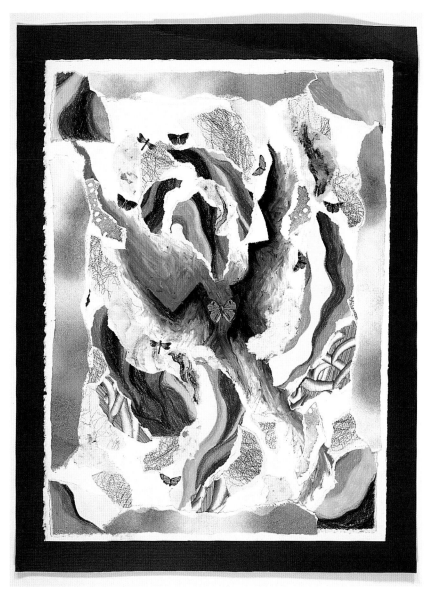

Wonderland *11" x 15"* *Lori Mason*
Wonderland - *Centering around Alice's Adventures in Wonderland, by Lewis Carroll, an abstract drawing, using oil pastels, was the starting point. Old watercolors and drawings were torn and adhered to form abstract representations of wonder, chaos, and emotion. A border made from an old watercolor becomes a frame around the entire image, representing containment and control. Very small butterfly images were added representing transformation.*

All Grown Up *22" x 30"* Lori Mason

All Grown Up - Pages of an old copy of "Alice" were randomly adhered onto paper, and a small circle was cut out of the center and replaced with a color-copied photograph of the artist as a child, which was stitched on. Pastel was used as dramatic accents.

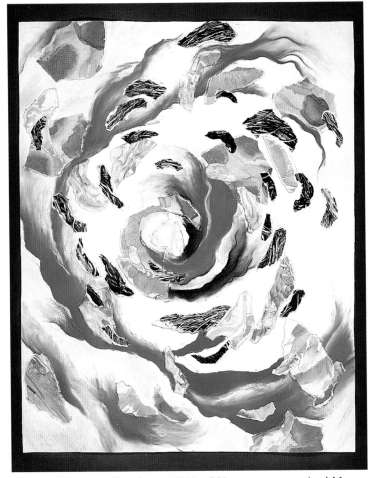

Descending Recollections - Old watercolors and monoprints were recycled for this collage drawing. A spiral, a vortex, a helix is formed from simultaneously drawing with pastels and adhering the torn pieces. This created an overlapping of paper and pastel. The light use of the pastels give it an almost watercolor feel, which is a pleasant contrast to the stark black monoprinted pieces.

Descending Recollections *18½" x 23"* Lori Mason

118

TONI MCCORKLE

"I love the idea of using bits of this and that to create something from nothing. For collage is a way of painting on paper without using a brush."

The pen, ink, watercolors, or acrylics on paper, metal, or wood are the materials of choice. The inclusion of traditional frakturs in contemporary form elevate the pieces to art.

Museums and individuals alike enjoy Toni's whimsical collages, as well as her other art. People such as Richard Simmons, George and Barbara Bush, and John Travolta have collected her work. Toni is the designer of primitive-style "Home*Body" dolls. These assemblage-style dolls have a primitive style and includes embroidery, beads, applique and more. Toni works and lives in Florida with her son, Dustin.

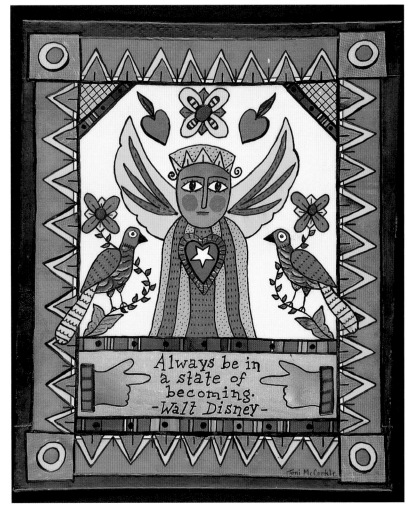

A State of Becoming *7" x 8¼"* *Toni McCorkle*

I See the Moon 5¾" x 6¾" Toni McCorkle

The Owl and the Pussycat *- A plan was formulated with a simple piece of recycled metal. Colors were selected from magazine pages and textural cutouts. The small swatches of paper were adhered onto the metal, previously sprayed black. A synthetic coating of porcelain then gave it a soft matte finish. A few details with ink resulted in a very detailed, whimsically intimate piece.*

The Owl and the Pussycat 5" x 7" Toni McCorkle

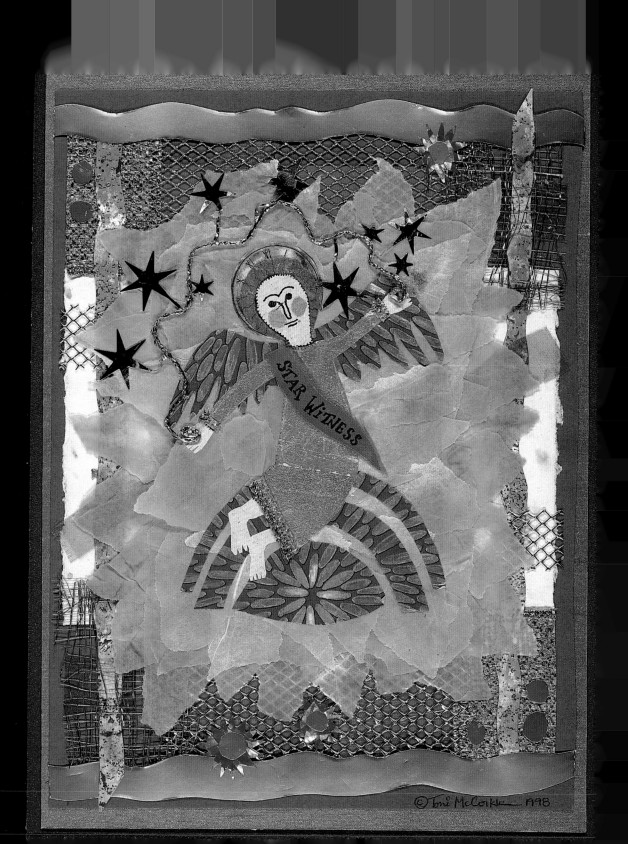

Star Witness - Inspired by an angelic fraktur drawing, and using a variety of papers, objects, and scrap findings, imagination frolics and inventive collage prevails. Delightfully fanciful, bright colors, interesting textures, and numerous layers create a low-relief collage, heavenly sent.

Star Witness 9" x 12"

LISA RENNER

"As a child, I enjoyed experimenting with various materials, colors, and textures by making books and puzzles for my brothers. I discovered rubber stamping approximately eight years ago. It was a natural evolution from rubber stamping to the paper arts." Texas is home for Lisa and her family, where she enjoys music, cooking, teaching rubber stamping, and mixed-media art, as well as spending free time in her studio.

Moon Book - *Mixed-media rubber stamping, embossing, decorative papers, and polymer clay were used for this accordion-fold book.*

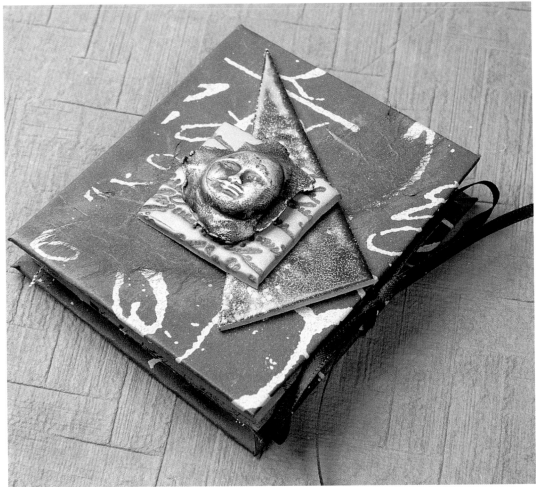

Moon Book *4" x 4½"*

Lisa Renner

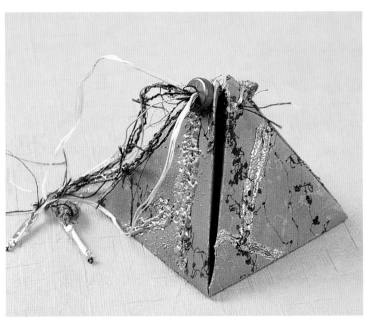

Pyramid Book - Liberal use of rubber stamping, embossing, decorative papers, mica-based pigments and flakes, and polymer clay embellishes this interestingly constructed book. The nontraditional shape opens to reveal small triangular "pages" tucked into decorative folds.

Pyramid Book *4" x 4" x 4"* Lisa Renner

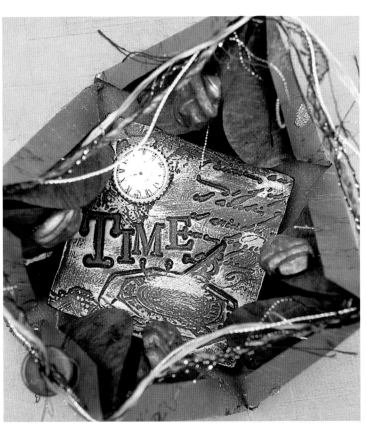

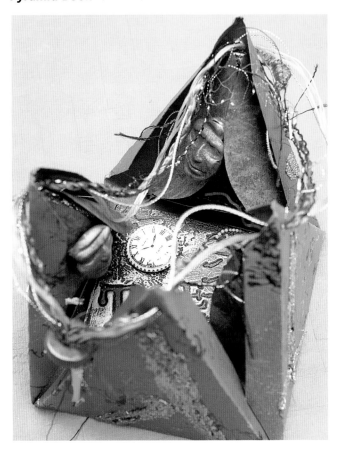

WILLIE TORBERT

A professional artist, Willie resides in Brooklyn, New York. He attended Medgar Evers College, City College, and Pratt Institute. Having four children of his own, he enjoys working with neighborhood children. Whether it be art or gymnastics, he encourages sportsmanship and encourages them to reach their fullest creative potential.

Torbert is the founder of Zakiya Art Gallery, a jewel in the Bedford-Stuyvesant community. His work reflects his artist's statement that he is "the eyes of my people." Willie's work is collected by celebrities, such as Cicely Tison, Natalie Cole, Sinbad, and Spike Lee.

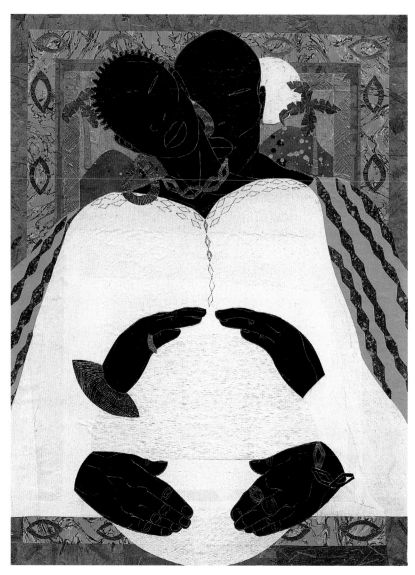

Hands On *25" x 33½"* *Willie Torbert*

***Hands On** - Heavily textured papers create diverse layers in this painting, done as a tribute to maternity and support of spousal involvement. Basic concepts of graphic design were used to produce contrast. The use of borders gives this piece a three-dimensional quality.*

124

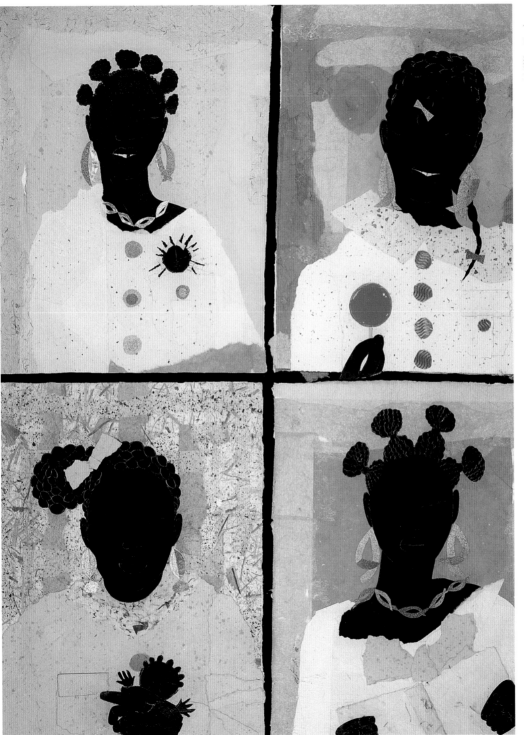

Willie Torbert

Young Girl Series - *"The four girls are a part of a ten-part series. The subject matter consists of girls with books, flowers, dolls, and candy. This series was influenced by my daughter, Zakiya. The jewelry presents a mature yet girlish quality. Pastels were used on layered surfaces of watercolor paper, for a natural and innocent feel."*

Young Girl Series *17½" x 22" each*

Glossary

A

Acid-free—Art materials or papers manufactured under neutral or alkaline conditions. Papers are often internally or externally buffered with substances that neutralize environmental pollutants and prevent deterioration.

Acrylic adhesive—An acrylic resin-based adhesive. Features include nonyellowing, nontoxic, and rapid-drying, with a matte or gloss finish.

Acrylic colors or paints—A pigment suspended in an acrylic resin. Features include nonyellowing, nontoxic and rapid-drying. Artist tube colors generally have more pigment and less fillers. Craft paints are more liquid, ready-to-use, and less color-saturated.

Assemblage—A combination of two-dimensional and three-dimensional elements assembled, layered, or integrated to create a single artwork.

B

Beating—Macerating fibers into pulp for sheet formation.

Bleed—1. The feathering of ink or paints into a sheet of paper. 2. Edges of artwork which run off the sides of the paper, particularly used as a printer's term.

Bone folder—A tool of bone used to score and fold paper evenly and accurately without bruising the sheet.

Brayer—An acrylic, rubber, plastic, or wood roller used for smoothing out air bubbles from a surface, applying inks and paint, and used for decorative applications.

Bristol board—A durable art board that is available in various thicknesses, and can be used as the base in lightweight collage work.

C

Cellulose—The chief component of plant tissue used as an adhesive or sizing agent.

Cockling—An undulating surface occurring in paper, usually caused by uneven drying and/or overwetting after paper has been dried.

Collage—A two-dimensional art technique whereby various low-relief papers, fabrics, or natural or manufactured materials are adhered to a surface.

Color—Primary: The colors red, yellow, and blue, from which all other colors are made. Secondary: The colors violet (red and blue), orange (red and yellow), and green (yellow and blue), which are the result of mixing primary colors. Tertiary: Any hue produced by mixture of primary and secondary, or two secondary colors.

Color copies—A mechanical means of reproducing in color an existing piece of art or photograph.

Composition—When elements of art are put together to achieve a particular pattern or design.

Composition leaf—A mixture of metal alloys that are made into the thinnest of sheets, called leaves, for use in gilding.

Contrast—Images, colors, papers, or textures that are different, yet work together for the overall balance of an artwork.

Couching—(coo-ching) Traditional method of transferring newly-made paper from the mould onto a felt or blanket for drying.

D

Deckle—Removable frame that sits on top of mould to hold layer of pulp and determines the size of a sheet in paper making.

Deckle edge—The distinctive feathered edge created by the deckle on a sheet of handmade paper. Can be imitated by a hand method of wetting and tearing paper.

Découpage—Similar to collage, but differing by the subject and the finishing techniques necessary to create a smoother, less textural surface. Usually more figurative than collage.

Dyes—Soluble coloring agents which penetrate the structure of a paper or textile fiber and become adhered to it.

E

Embedding—Incorporating materials in a sheet of paper, polymer clay, or other material, so embedded material is held in place.

Embossing—1. Wet or dry: A raised or depressed area in paper caused by pressure or a three-dimensional object. (A depressed area is often referred to as "Debossing".) 2. Thermal: The creation of a raised surface caused by applying a wet substance, attaching fine granules of embossing powder, and heating at high temperatures.

Embossing powder—A clear or colored powder resin substance that can be heated to achieve a thermally embossed surface.

Encaustic—A high-grade wax mixed with pigment and used as an ancient method of painting.

Epoxy resin—A powerful chemical adhesive made of two parts, a hardener (catalyst) and a glue. Used for adhering heavy or bulky objects to a ground.

F

Felt—In paper-making, the blanket onto which a sheet of paper is transferred, or couched.

Fiber—The thread-like structure in plant tissue from which paper-making pulp and textiles are made.

Fixative—1. Workable: A liquid that is generally sprayed onto artwork containing a binder to protect and seal a piece. It is especially good for pastel, pencil and charcoal drawings to keep them from being smudged. Workable fixative can be continually drawn, painted, collaged upon, while still keeping binding effects. 2. Unworkable: The fixative cannot be worked upon after being applied, and acts as a resistant to the art materials. Can be used as a finishing spray. Permanently affixes medium to surface of paper.

Frottage—An image made by placing paper or cloth over a relief surface, rubbing with a colored substance, and creating the pattern of the original surface.

G

Gel medium—A heavy, glossy, transparent acrylic resin used as an adhesive, paint extender, or varnish.

Gesso—A high-quality primer used for adding texture and support.

Glazing—Applying a layer of color (pigment or paper) over another while allowing levels of the undercolor to show through.

Glue—An adhesive to join surfaces, or used in a weak solution as sizing.

Gouache—An opaque watercolor paint.

Gradation—Gradual change of any element of design.

Grain—The alignment of wood or paper fibers.

Gum arabic—A water-soluble resin medium mixed with wet or dry pigment to create watercolor paint. Also a binder in printmaking.

I

Illustration board—A medium-weight board used for the base of collage.

Ink—A fluid, semifluid or paste material containing pigment.

L

Lightfast—The ability of a colored substance to withstand exposure to daylight without fading or changing color.

M

Mat—A stiff cardboard cut-out in the center to form a border between the outer edges of a picture and inner edge of frame.

Mat board—A thin, stiff, good-quality cardboard, which comes in hundreds of colors, used to make mats in framing pictures.

Mica—A complex heat-resistant silicate occurring naturally in several colors of laminated plate form, flakes, granules, and powders.

Mixed-media—The use of two or more media in a single work of art.

Mould—In paper-making, the frame on which the sheet of pulp is formed, usually made from wood and covered with a fine mesh, laid or woven, wire surface.

Monochrome or monochromatic—A single color image.

Montage—The joining of several images or materials to form a single image, particularly photographs.

P

Paper casting—Making dimensional paper pieces, usually by moulding.

Papîer maché—A moulding material made of paper torn into strips or pulped and soaked in a binder, usually flour or starch.

Paper making—Making paper from pulp by either a mechanical or a hand-making process.

Paste paper—Decorating paper by using a preparation of pigment and paste or adhesive.

Patina—A film that forms on copper and bronze due to a certain amount of weathering, and can be obtained either naturally or artificially.

pH—Denotes the degree of acidity or alkalinity of a substance.

Pochoir—Creating stenciled textures and patterns with positive image.

Post—The pile of newly formed paper sheets alternated with couching felts, ready for pressing.

Pulp—The aqueous mixture of ground-up fibrous material from which paper is made.

R

Rag paper—A high-quality cotton paper with excellent archival properties.

Resist—Any substance used to block out or temporarily mask a surface area.

S

Size—1. A substance used to make paper less absorbent; it may be added to pulp during paper making, or applied to a finished sheet. 2. A solution in which marbling colors are floated.

Stamping—To decorate a surface, using a device made of rubber or otherwise, that will create a repetition of pattern.

Stenciling—To decorate a surface, using a cutout pattern and paint through the cutout areas.

U

Underpainting—The preliminary layers of color on a painting surface that are beneath the final coat.

V

Value—The contrast between light and dark on a scale that moves from light to dark (i.e. white to black, pastel pink to dark red.)

Varnish—A translucent finish used as an adhesive, paint extender, and protectant.

Vellum—Parchment paper, traditionally made from skins of newborn calves, kids, or lambs.

Verdigris—The green patina that is formed on copper and bronze because of oxidation.

W

Watercolor—A translucent water-based pigment.

Acknowledgments

We would like to offer our appreciation of the valuable support given in this ever-changing industry of new ideas, concepts, designs, and products. Several projects shown in this publication were created with the outstanding and innovative products developed by:

USArtQuest, Inc.
7800 Ann Arbor Road
Grass Lake, MI 49240

Adhesive: Perfect Paper Adhesive
Dry pigment: Jacquard Pearl Ex
Mica tiles: Perfect fx
Tape: Ah, That's Great Tape
Brushes: Perfect Brush Trio
Gum Arabic
Webbing & glitter sprays: Krylon

Additional materials used:
Paints:
Golden Artist Colors
188 Bell Road
New Berlin, NY 13411

Embossing inks:
Ranger Industries
15 Park Rd.
Tinton Falls, NJ 07724

Airbrush system:
Esselte Corp.
71 Clinton Rd.
Garden City, NY 11530

Crackle medium:
Delta
2550 Pellissier Pl.
Whittier, CA 90601

Crystal gel:
Pebeo of America
Airport Rd.
P.O. Box 717
Swanton, VT 05488

Stamps:
Co-Motion
2711 East Elvira Rd.
Tucson, AZ 85706

Hot Potatoes
2805 Columbine Pl.
Nashville, TN 37204

Magenta
351 Blain
Mont-Saint-Hilaire
Quebec J3H3B4

Rubber Stampede
967 Stanford Ave
Oakland, CA 94608

Stamp Francisco
12489th Ave.
San Francisco, CA 94122

Stampers Anonymous
P.O. Box 16091
Rocky River, OH 44116

Stampington & Co.
22992 Mill Creek Suite B
Laguna Hills, CA 92653

Metric Conversion Chart

Inches to Millimetres and Centimetres

Inches	MM	CM
⅛	3	0.9
¼	6	0.6
⅜	10	1.0
½	13	1.3
⅝	16	1.6
¾	19	1.9
⅞	22	2.2
1	25	2.5
1¼	32	3.2
1½	38	3.8
1¾	44	4.4
2	51	5.1
2½	64	6.4
3	76	7.6
3½	89	8.9
4	102	10.2
4½	114	11.4
5	127	12.7
6	152	15.2
7	178	17.8
8	203	20.3
9	229	22.9
10	254	25.4
11	279	27.9
12	305	30.5
13	330	33.0
14	356	35.6
15	381	38.1
16	406	40.6
17	432	43.2
18	457	45.7
19	483	48.3
20	508	50.8

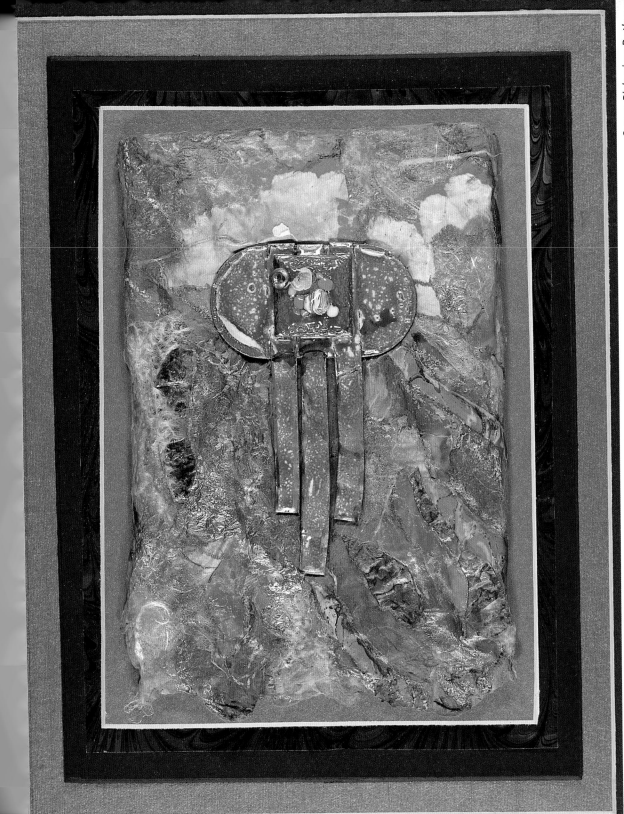

"And God said, Let there be a firmament in the midst of the waters, and let it divide the waters from the waters. And God made the firmament, and divided the waters which were under the firmament from the waters which were above the firmament: and it was so. And God called the f i r m a m e n t Heaven. And the evening and the morning were the second day."
Genesis 1:6-9

The Second Day *12" x 16"*

About the Author

After 25 years, Susan Pickering Rothamel calls Michigan home, but is quick to point out that she originally hails from Bucks County, Pennsylvania—an area rich in history and well-known for its very diverse art community. Creative in their own right, her parents, siblings, an extra-ordinarily loving aunt, and friends all played crucial roles in encouraging the development of Susan's art. Working in a wide artistic arena of distinctly different art forms, Susan is able to take watercolor, pastels, encaustics, copper enameling, pottery, and oil painting and construct, then deconstruct, allowing them to come together once again, merging into one analogous piece of art. "The evolution of a piece of art I complete today probably started with a found object collected or piece of recycled artwork started many years ago. It's the excitement found in the textural qualities of mixed-media work and the enchantment of paper that continually delight me." Using contemporary imagery, she incorporates Biblical themes into much of her work. Using her broad knowledge of principals of color, material knowledge, and archival integrity, Susan relates her genuine enthusiasm for art to others in many ways. Susan is part owner of USArtQuest, Inc., an art materials company which develops unique and unusual products, offered with a decidedly educational slant. Teaching classes since 1979, she is experienced as a national lecturer, writer, and product and marketing consultant. She has spread her excitement for the arts through workshops, classes, articles, and instructional videos. Susan's column "The Business of Art", seen bimonthly in *Somerset Studio* magazine, offers the novice and professional artist practical business advice.